Negrophilia

Avant-Garde Paris and Black Culture
in the 1920s

Negrophilia

Avant-Garde Paris and Black Culture in the 1920s

Petrine Archer-Straw

With 123 illustrations

Thames & Hudson

© 2000 Petrine Archer-Straw

First published in paperback in the United States of America in 2000 by
Thames & Hudson Inc., 500 Fifth Avenue, New York, New York 10110

thamesandhudsonusa.com

Library of Congress Catalog Card Number 99-69806
ISBN 0-500-28135-1

Printed and bound in Singapore by CS Graphics

Contents

The word 'negro' was often used during the 1920s to describe people of African origin. In this book it is employed only in the context of the period. Apart from this usage, I prefer as descriptors the more general and politicized word 'black' or specific definitions such as 'African-American' or 'Afro-Caribbean'. 'White' is used here to describe people of European origin.

Petrine Archer-Straw
September 1999

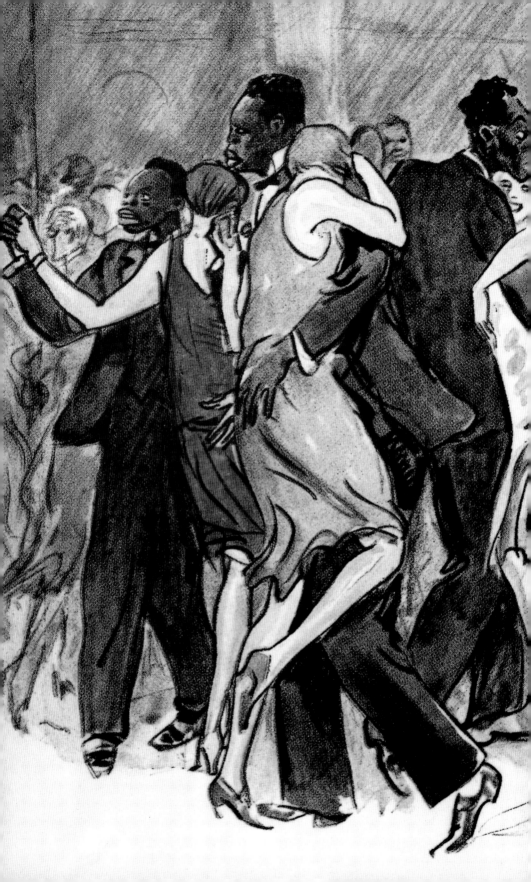

Negrophilia is about how the white avant-garde in Paris responded to black people during the 1920s, when interest in black culture became highly fashionable and a sign of being modern. The book traces the development of the negrophilia craze from an era of traditional stereotyping of blacks in the nineteenth century to one of more modern images influenced by African sculpture and contemporary African-American culture. Concentrating on the decade 1920–30, it looks at how art resulting from a clash of black and white cultures in the 'jazz age' both reflected the European avant-garde artist's anarchic interests and challenged prevailing colonialist views. Advertisements, painting, sculpture, photography, popular music, dance and theatre, literature, journalism, furniture design, fashion and *objets d'art* – all are scrutinized to see how black forms were appropriated, adapted and vulgarized by whites. The book also raises questions about the avant-garde's motives, and suggests reasons and meanings for its interest. The personalities whose lives, loves, images and ideas pioneered the passion for black culture are central to the discussion. Their 'African' style influenced a larger European audience anxious to be in vogue.

'Negrophilia', from the French *négrophilie*, means a love for black culture.[1] In the 1920s, the term was used positively by the Parisian avant-garde to affirm their defiant love of the negro. The word's origins, however, are not so flattering. To be called a 'negrophile' or 'nigger lover' in the nineteenth century was to be damned as a supporter of liberal attitudes towards slavery and its abolition. Even more negatively, negrophiles were sometimes accused of having a deviant sexual appetite for blacks, thereby placing them outside 'civilized' society's moral boundaries.

Today, many might want to forget such words, believing that they have no place in any society that is conscientiously and overtly attempting to rid itself of bigotry and xenophobia. But 'Negrophilia' is an apt title for a book that explores the historical ambiguities and racial complexities of 1920s Paris. As used by the Parisian avant-garde, the word was meant to be provocative and challenging to bourgeois values. Now,

SEM *Le Bal de la rue Blomet, Paris*, 1923 (detail)

however, it is being redeployed to examine aspects of Western thinking itself. It joins a list of other words popular in the nineteenth century, such as 'primitive', 'tribal', 'savage' and 'civilized', that today can tell us more about the societies that used them than the ones they were supposed to describe. Such introspection is an important tool for analysing the negrophile misfits of the colonial period.

Negrophilia grew out of my studies of primitivism in the 1980s. I was aware that although art historians discussed black culture's influence on the Parisian avant-garde there was no text that looked at the avant-garde's motivations outside of artistic imperatives. Redressing this imbalance called for an examination of rarely considered tropes within European art history that reinforced negative stereotypes of blacks, especially in respect to primitivism. Further, when the relationship between black people and Parisian artists was addressed, it was often glamorized with jazzy language and flagrant descriptions that contrasted sharply with other areas of modernist discourse. It was as though the mere mention of black culture called for a lightening of the spirit and for more-frivolous prose. It seemed that even my own writing was affected by perceptions of the period. I was curious to know why black culture's influence on 1920s Paris had been framed in this way, and keen to test the validity of its up-beat image. I wanted *Negrophilia* to offer a critique of nineteenth- and early twentieth-century primitivism. This required a closer reading, and a questioning of European ideas of the primitive.

In 1984, art history's interest in these ideas revived as a result of the exhibition ' "Primitivism" in 20th Century Art', staged at The Museum of Modern Art in New York. In the catalogue accompanying the exhibition, curator William Rubin provided an art-historical appraisal of primitivism to show how twentieth-century artists came to appreciate art forms from other cultures such as Africa.[2] He explained that when artists called art 'primitive' they meant it as a term of praise. He employed their positive response to other cultures and their use of the term 'primitivism' to justify the title of the exhibition and the catalogue.

Rubin was correct in saying that for members of the Parisian avant-garde the 'primitive' was an antidote to a stifling and civilizing bourgeois modernity; but their positive use of the word could not avoid the negative connotations that it had acquired, particularly during the nineteenth century. Rubin refused to acknowledge these associations, and instead insisted on separating the art-historical meaning of 'primitive' from its more dubious connections with nineteenth-century race theories. He distinguished art history's 'Primitivism' by giving the word a capital 'P' and by placing it between quotes. His labelling of

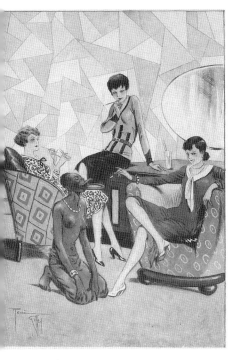

RENÉ GIFFEY 'The personnel crisis – The true maid – Batoualette, very practical ashtray at drinks', from *Fantasio*, 1 November 1929

'It's only a massage, Madame ... given by the Savage slimming machine', a French advertisement, 1929

the MOMA exhibition showed that little had been done to challenge the nineteenth-century ideology that had shaped and defined primitivism.

Although the term 'primitive' is now more often used within art history to describe the cruder, non-classical painting of medieval Italians, its application from the middle of the nineteenth century onwards to works and people from other cultures was directly related to an intellectual interest in racial difference. 'Primitive' was the bottom line in a hierarchy of categories that placed European civilization at its pinnacle. The Parisian avant-garde exploited the word's more negative readings – its links with blackness, savagery and deviance – because it suited their need to outrage. It also expressed their romanticized interest in origins, the prehistoric, the archaic and meso-American cultures.

Whether the term 'primitive' has any descriptive validity at all with regard to other cultures is questionable. It was a label conferred by nine-teenth-century Europeans in an act of *self*-definition. The 'Primitive' was created to be oppositional to or to complement the Western rational 'I'.

The Primitive represented the process through which Europeans suggested their own superiority by placing inferior status on others. This process was entirely one-sided: it was simply a way for Europeans to project their fear of difference onto other races.

Even though in its strictest sense European colonial rule has long been surrendered, its 'civilizing' mission remains influential. The language inherited from the colonial era is still prevalent enough and potent enough to affect how other cultures are described. *First world* versus *third world*, *developed* versus *underdeveloped*, *West* versus *the rest* are paired opposites just like *savage* versus *civilized*. These constructs stem from colonialism's binary way of thinking, which through language enforced European superiority. Terms such as 'primitive' and 'primitivism' are similar expressions of this power relationship and thus need to be re-examined and replaced. They form part of the outstanding debt not yet settled between the colonizer and the colonized.

If primitivism is viewed as a product of the European psyche, then what seems to be a relationship between two parties – the 'civilized' and the 'savage' – is in fact singular, involving only the self and its actions. If any duality exists it is in the act of one party 'primitivizing' the other. So this book changes perspective, looking only at the 'primitivized', rather than the 'primitive'.

This shift in focus redirects our attention inwards, and suggests a way of viewing history that is introspective and self-critical. It challenges terms often taken for granted that point a finger outwards and allow for self-avoidance. It brings a new awareness of how relationships with people from other cultures are perceived and articulated. By taking a close look at the language and visual expressions of the early years of the twentieth century, this book teases out the prejudices that still pander to European taste and sensibility. In doing so, it challenges the more usual 'Eurocentric' art-historical writing about other cultures: *Negrophilia*'s perspective is essentially non-European.

The need for a revolutionary use of language to level the playing field was one of the first concerns of the 'negritude' poets of the 1950s, who represented a 'neo-colonial' movement for change.[3] 'Negritude' itself was a neologism coined by the Martiniquan poet Aimé Cesaire to challenge Western fallacies about black culture and literature. Similarly, literary theorist Edward Said's seminal work of the 1970s, *Orientalism*, stemmed from a literary and critical tradition that challenged European discourse.[4] In much the same way that neologisms like 'negritude' and 'orientalism' are used, the term 'negrophilia' finds a new twist here. Its revamping is designed to oppose diametrically the historical and nega-

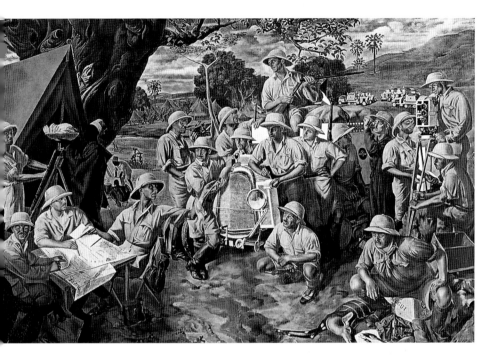

ALEXANDRE IACOVLEFF *The Expedition Team*, one of the paintings produced by Iacovleff after the 1925 'La Croisière noire' expedition across Africa, of which he was the official artist, 1927

tive conceptual connotations of primitivism. Consequently, this book focuses primarily and critically on the actions of the white or European partner in the negrophiliac relationship, unlike other approaches that are more preoccupied with mythologizing the black and black culture.

Europe's 'conquering' of Africa and the 'new world', and its exploration and discovery of different cultures, created 'primitive' types and functioned as a kind of collective therapy to maintain European esteem and belief in its various nationalisms. In a sense, Western cultural arrogance could be assured and sustained only through the exercise of colonialism. Beyond Europe's primary motive to exploit Africa's human and environmental resources, conquering 'the dark continent' allowed Europeans to act out roles and to reinforce notions of control. The reality of the black man and the mystery of the land he represented became fertile psychological landscapes in which the white man could create and satisfy his desires. The line of demarcation between the real and the unreal became increasingly blurred. For Europeans, Africa and the black man were framed in notions of high adventure, savagery, fear, peril and death. Products of the outer reaches of the imagination, these fantasies

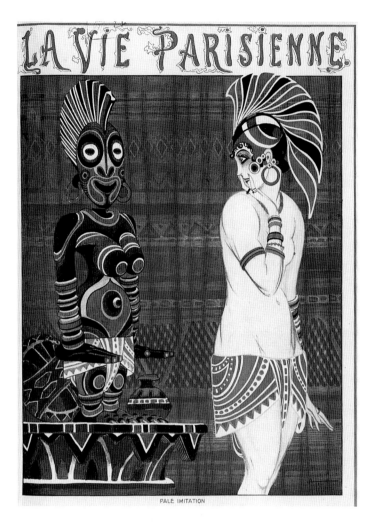

PALE IMITATION

'Pale imitation', from *La Vie parisienne*, 25 October 1919

necessitated distance in real and psychological terms. 'Africa' and 'blackness' were merely signifiers of the unknown, however, and as such could be applied to any culture or race. Similar notions of intrigue could be used in reference to the native American 'Indian', or to an infatuation with the Near East (orientalism), the Far East (*japonisme*) or the Pacific Islands (melanomania).

In the negrophiliac relationship, both Europeans and Africans owned stereotypical views about each other. They formed what can be called an 'other' relationship whereby their attraction fed off their dif-

ferences rather than their similarities. The process of 'othering' allowed both partners to act out myths and fantasies. For whites, the negrophiliac relationship provided a space for rebellion against social norms. They naïvely considered blacks to be more vital, more passionate and more sexual. Their fantasies were about being different, even about being black. Living out these ideas involved 'getting down' with black people. No social evening was complete without black musicians and dancers. Even aristocrats such as Baroness de Rothschild, Countess de Noailles and the Prince of Wales fraternized with black people, and entertainers like Ada 'Bricktop' Smith, Josephine Baker and Cole Porter found themselves in demand at charleston parties held in wealthy homes. For some whites, the fantasies went beyond 'high jinks and dancing' and involved flaunting taboos by dating blacks. For black

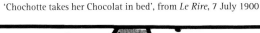

'Chochotte takes her Chocolat in bed', from *Le Rire*, 7 July 1900

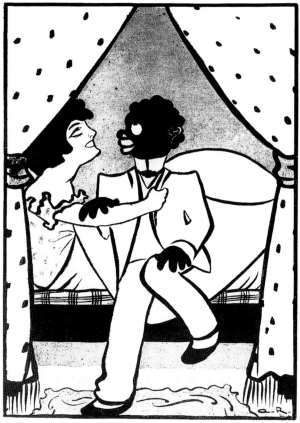

people, the attraction for the 'other' was equally strong, the negrophiliac relationship validating their sense of worth. Accessibility to whites and their lifestyles gave them a sense of power, albeit a limited one. Life in Paris afforded them freedoms and excesses rarely experienced by blacks in America: they believed themselves equal.

Negrophilia is about how the two partners of this relationship negotiated their identities in the Parisian milieu of the 1920s. In that era, 'the black' and 'the white' came face to face with each other's realities and dreams. How they related, circumvented each other by alternately concealing and exploiting their differences, and redefined themselves as a result is explored here.

Paris of the 1920s offers several advantages for highlighting the cultural paradigms introduced in this book. The artistic climate then was sensitive and experimental, as reflected in its *mélange* of modernist art styles. African art's influence on the Parisian avant-garde in the prewar years had stimulated such works as Picasso's *Les Demoiselles d'Avignon* (1907), and subsequently black forms were slowly absorbed into the Cubist vocabulary. Amid the hyper-inflation of the 1920s and a sense of hysterical optimism, Art Deco, Cubism's design offspring, became a commercially successful style. By the end of the decade the African forms that had provided an initial spark to the modernist vision had become the icing on the cake.

The black forms that Parisian artists fetishized varied from wood and stone carvings (trophies from African expeditions) to 'live' African models posing in the artist's studio. African sculpture, up to then the preserve of explorers and ethnographers, had spent years neglected in dank museums such as the Trocadéro in Paris awaiting its (re)discovery. Only at the beginning of the twentieth century was it recognized as a source for fresh artistic ideas and Cubist problem-solving. Similarly, in the years following the First World War, real Africans and African-Americans were celebrated for the entertaining remedies they provided for the ailments of modern life. In jazz nightclubs, urbanites and the avant-garde could have physical contact with blacks to lend fact to their fantasies.

After the First World War, Africans and African-Americans who had served in Europe stayed there or returned there because they saw better employment opportunities and the chance to enjoy social mobility. They found fewer racial restrictions in Paris than existed in America, and began to develop a new sense of identity as their social status improved. But their place in the power structure remained the same: the white man was still master in economic terms; only the context changed, from one urban setting to another.

Further emigration of blacks to the cities of Europe meant even more contact with urban whites and provided a new common ground for both groups. The two races were intrigued with their new bedfellows (so to speak, given the sexual nature of many initial meetings). Still, the relationship was a superficial one: the myth of the black man was now substantiated with the proliferation of his image based on a cursory assessment. Enter *Vogue*'s depiction of the 'New Negro', a type that came straight out of white fantasies, with all the old traits of the savage and the erotic concealed beneath street-smart suiting. Of course, this 'new negro' had nothing to do with the one the intellectuals around the Harlem Renaissance were busy defining. He was closer to an American Jim Dandy, an effete and overdressed travesty.

A similar process of reappraisal was also taking place as far as the role of women in society was concerned: they, too, had experienced a change of circumstance reinforced by the war. It was a difficult transition for the white male artist to come to terms with, caught as he was between seeing the female as subject of erotic fantasy or as idealistic

MIGUEL COVARRUBIAS 'Enter the New Negro', from *Vogue*, April 1927

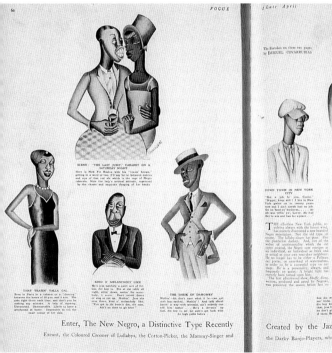
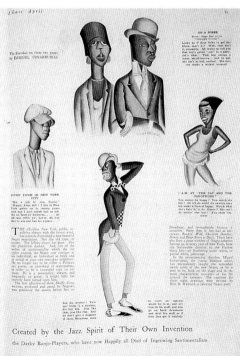

muse. This ambivalence towards women, combined with those about race, added to the collage of images produced during the 1920s.

That Paris rather than New York, London or Berlin should be the city where these notions were played out is understandable, if not predictable. The French capital had long been a haven for émigrés such as White Russians and Europe's Jews, offering tolerance and even appreciation of cultural diversity. Postwar Paris welcomed African-American soldiers who did not want to return to America's racial restrictions. The city's acceptance of black culture contrasted sharply with America's racial bigotry. Its reputation as the bohemian capital meant that it also attracted itinerant black artists, writers and musicians keen to imbibe and join its street culture, avant-garde exhibitions and nightclubs. Paris's modernity was characterized by its openness to black culture and jazz in particular, the improvised and anarchic musical form that seemed to sum up the unpredictability and anxieties of a new age. For the fragile Parisian psyche, susceptible to wave after wave of new crazes, negrophilia was just another fashion like *chinoiserie*, *japonisme* and *mélanomanie*, to be sported and then discarded. Yet, for all negrophilia's superficial qualities, and Paris's desire for the vogue, there was an underlying integrity that stemmed from the French credo '*liberté*, *égalité, fraternité*'. There was also an honesty about Paris's need for black culture that stemmed from lost confidence in European rationalism, science and materialism. In the aftermath of a debilitating war, Paris's intellectuals and avant-garde were the first to question Europe's material and moral progress and its 'civilizing' mission.

Unlike that of their British neighbours, French interest in their colonized peoples went beyond economic considerations. The avant-garde's admiration and borrowing of negro forms was as much to satisfy its own need for the 'exotic' and the 'real' (something that was lacking in its own culture) as it was economic exploitation. The allure of black culture was that it stood for a spiritual wholeness that had been obscured in an increasingly 'civilized' and mechanized environment by layers of material development. The assimilation of black forms into Parisian subculture was remedial and therapeutic. The Parisian artist became a modern primitive who acted out a ritual function as magician or shaman by absorbing and re-creating these fetishes in his work. Thus the image and depiction of 'blackness' served as an antedote for easing the psychic and spiritual needs of its dislocated and disenchanted bohemian society.

Why the Parisian avant-garde chose to primitivize black culture can be understood by taking a closer look at the cultivated lifestyles of the negrophiles of the 1920s. The photographs, writings and memorabilia of

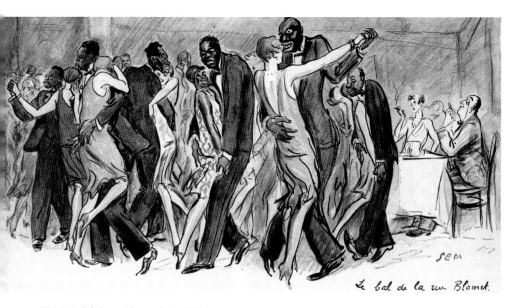

SEM *Le Bal de la rue Blomet, Paris,* 1923

figures such as the poet Guillaume Apollinaire, the African-art collector
Paul Guillaume, the shipping heiress and publisher Nancy Cunard, and
the dissident surrealist Michel Leiris all re-create the atmosphere of a
city in the grip of a *virus noir.* The world of these negrophiles centred
around the jazz haunts of Montmartre and Montparnasse, the *soirées
nègres,* and the self-conscious posturing that the influence of
Hollywood's burgeoning film industry, photography, fast cars and
fashion provoked. The negrophiles who fraternized with blacks culti-
vated a shadowy world of nightclubs and bohemianism; their interests
were in conflict with mainstream, 'traditional' values. 'Blackness' was a
sign of their modernity, reflected in the African sculptures that scattered
their rooms, in the look of natural furs that fringed their coats, and in the
frenzy of their dancing that mimicked the black bottom. Only rarely are
black people depicted in this world. They and their mystique are the
invisible presence in a multitude of negrophiliac images and texts from
the era; their anonymity is fused with the fashion, style and fetish-
ridden interiors that are integral to this book. A reading of what such
images and texts communicated to their audiences requires an under-
standing of a complex semiology of signs and symbols whereby every
mark has a history of silent meaning. The developments of some of these
stereotypes, and questions about the way they were used by the avant-
garde, are of concern here.

The blacks who found themselves in Paris were courted for their sense of style and vitality. Some were discharged soldiers anxious not to return to the racial restrictions of North America as harshly spelt out by the black activist William Edward Burghardt Du Bois in his 1919 *Crisis* editorial 'Returning soldiers'.[5] Jamaican writer Claude McKay's novel *Banjo* aptly describes their improvised lives in Europe, calling them 'black monkeys ... created by the conquest of civilisation'.[6] Many were musicians and entertainers, such as Josephine Baker and Sidney Bechet from the *La Revue nègre* troupe and Ada 'Bricktop' Smith, who found that white interest in the charleston, lindy hop, black bottom and shimmy dances could earn them a significant income. So they stayed.

But not all blacks in Paris were hustlers or entertainers. Many black intellectuals and artists came to the city because it was perceived as the centre of the artistic world. Like others, they wanted to participate in its mythic modernity, freer race relations, and artistic integrity. As Henry Crowder so optimistically stated in the 1934 anthology *Negro*, being coloured in France was 'never a mark of inferiority'.[7] James Weldon Johnson's statement that Paris gave him the 'freedom to be a man',[8] rather than a black man, suggested that the city allowed blacks to escape the burden of their blackness. Jack Johnson, Josephine Baker, Sidney Bechet, Claude McKay and Langston Hughes are just a few of the many blacks whose lives in Paris impacted on negrophilia. Their rarely stated views demonstrate the complexities of how blacks and whites related to each other and to their own identities during the 1920s.

In his book *The Black Atlantic*, Paul Gilroy describes what he calls 'cultural insiderism', a form of ethnic snobbism that perpetuates racial, cultural and national difference.[9] The converse applies to Paris in the 1920s. The avant-garde cultivated what can be called a 'cultural outsiderism' as a statement against the violence of nationalisms experienced during the war. It admired blacks for their sense of difference and for their links with another culture that it saw as primitive and therefore positive. Meanwhile, blacks who travelled to Paris hoped that they could exchange their historical sense of displacement and dislocation for membership in the avant-garde's postwar cosmopolitanism. They saw avant-garde patronage as a route to international status. But they were ill-equipped for Paris's bohemian culture and the distortions they had to endure for their ambitions.

By comparing the aspirations and conditions of 'real' negroes with the lifestyles and ephemera of negrophiles, this book explores notions of 'otherness', 'identity' and 'masking' essential to any understanding of the darker side of Paris's modernity. *Negrophilia* suggests that it was

was the arbiter of civilization and had a monopoly over what was perceived to be rational behaviour. It was the white man alone who had the right to study, label and define those of other cultures, the labels 'savage' and 'primitive' being reserved for blacks, who were considered the least of the species. Within an evolutionary schematic, the black man was thus believed to occupy the lowest rung on the ladder: even his humanity was questioned. Such trends in nineteenth-century philosophical and scientific thought helped to shape popular stereotypes of blacks and to define them as primitive.

The presence of black people in European painting demonstrated their importance in conceptual, artistic and symbolic terms. In the eighteenth century, the image of blacks in portraiture could serve many different purposes. If they were represented as diminutive and adoring servants, they reflected their owner's status and wealth. Alternatively, after the French Revolution, when debates about race, intelligence and 'the noble savage' were philosophical preoccupations, making a black person the subject of a painting, or giving him equal status within it, such as in Anne-Louis Girodet's *Portrait of Citizen Belley* (*see page 26*), could communicate political statements about French humanitarianism and the victories of abolition and racial equality.[5]

Paintings of blacks also served to demonstrate an artist's technical skill and his ability to weave their portraits into the historical, mythological and biblical narrative scenes popular in French salons. In the first half of the nineteenth century, and into the second, as France's colonial preoccupation with North Africa and the Middle East, or what was popularly called the 'Orient', developed, the image of the black found a place in epic salon paintings such as Théodore Géricault's *Raft of the Medusa* (1819), Eugène Delacroix's *The Death of Sardanapalus* (1827; *see page 27*) and Jean-Auguste-Dominique Ingres's *Odalisque with a Slave* (1839). These artists' careful studies, verisimilitude and judicious painting of blacks ennobled their black models; but by placing blacks within imaginative, exotic, violent and sexualized settings they merely reinforced the use of the paintings as artistic tools and aids for the European imagination, thus implicating themselves within colonialism's racist agenda.

In painting, the process of 'othering' the black operated through the use of a powerful network of images and symbols that, by association, could conjure up deep-seated fears, the deepest of which were regression and loss of racial purity. The inclusion of black people in paintings summarized all the subliminal fears and phobias that posed a threat to nineteenth-century Western society. Spurious symbolism continued to link 'blackness' with sin, death, ignorance, sexual deviancy, virility,

fecundity – traits that at the same time validated 'whiteness' as pure, chastened and enlightened. Paintings were thus visual constructions that could be used to support prevailing racial myths about black people that had already been communicated in writing.

These ideas of blacks as a separate and subordinate species had, of course, been entrenched in the slavery movement, which in turn had inherited them from Christianity. Nineteenth-century scientific theories about race were an outgrowth of such religious thinking and came about

ANNE-LOUIS GIRODET *Portrait of Citizen Belley*, 1797

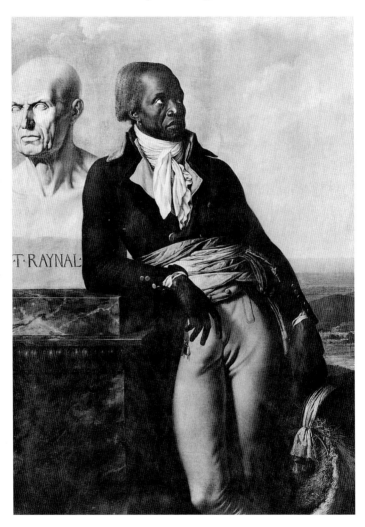

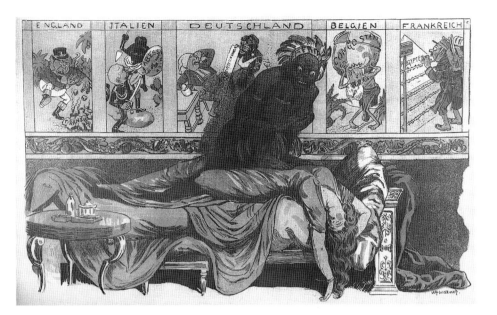

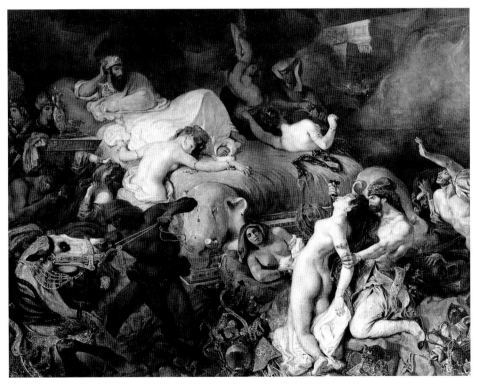

'Like a succubus, Africa weighs on the repose of Europe', parody of Fuseli's *Nightmare*, from *Le Rire*, 18 April 1896

EUGÈNE DELACROIX *The Death of Sardanapalus*, 1827

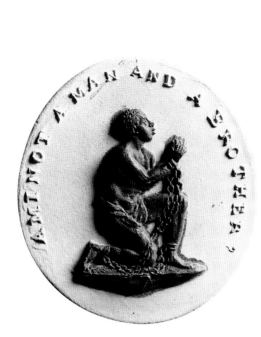

JOSIAH WEDGWOOD Seal designed for the Slave Emancipation Society, 1786

in direct response to abolition. The image of the black man on bended knee, enchained, yet uplifted by the prayer 'Am I not a man and a brother?', summarized this history of subordination, and it became the emblem of the abolitionists. But the image is at odds with the rhetorical question it poses. There is nothing equal or fraternal about the depiction. Most abolitionists, such as William Wilberforce, were not only committed Christians but also advocates of the new sciences that pioneered studies of race. It was their interest in race as a natural, scientific and cultural phenomenon that led them to an abhorrence of slavery, not a belief in the fundamental equality of blacks and whites. The abolitionists were thus responsible for their own myth-making, because they operated from the false premise of the black man's intellectual inferiority to the white man. The image of the slave's clasped hands, pleading gesture and subordinate position perfectly suited their needs. It reflected liberal European beliefs about what the black man ought to be, by conveying sympathy while maintaining the white liberator's sense of superiority.

Both religious beliefs and the evidence of the new sciences fed the ideology of a burgeoning colonialism that progressed out of slavery. Initially, colonialism used this ideology to justify its 'philanthropic' expansionism abroad; but eventually its motivation became more one of profit-making than one of philanthropy. The mainstay of colonialism, particularly in the Caribbean, was the transatlantic trade in products such as sugar, coffee, tobacco and rum; in Africa, it was the trade in minerals.

At the start of the nineteenth century, sub-Saharan Africa was relatively virgin territory for European exploration, which until then had centred around the establishment of trading posts along the coastline and the Cape Colony. Even with Europe's mercantilist interests, most of the European powers were reluctant to establish more formal relationships or to assume additional imperial responsibilities in Africa. From the middle of the century, much of the exploration of the continent's interior was based on the actions of highly motivated individuals, such as Henry Morton Stanley and David Livingstone in the Congo, the Frenchman Count Pierre-Paul-François-Camille Savorgnan de Brazza in Gabon, Harry Hamilton Johnston in Angola, Cecil Rhodes in southern Africa, and the German Carl Peters in eastern Africa. In the European mind, the adventures of these expeditioners were associated with notions of hazard, danger and heroism. For cxample, the painting and glass lantern slide which depicted the tale of Livingstone's innocuous encounter with a lion in a highly dramatic form became part of Victorian England's collective consciousness.[6]

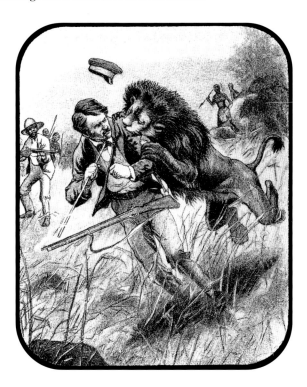

ANONYMOUS *Livingstone and the Lion*, glass lantern slide, c.1900

Such tales of adventure roused the interest of those back home in Europe, who were impressed with the novelty of travel. The press, travel journals and innovative picture postcards now reproduced previously only imagined scenes and accounts of faraway lands, both catering for and fanning the public's enthusiasm. From the 1860s, Africa operated on the levels of the real and the unreal, at once the site of civilizing missions and scientific expeditions and the 'heart of darkness' where every expedition was like a personal journey into the unknown to confront one's own fears and phobias. Africa was the dark continent in both geographical and psychological terms, fuelling fantasies for the driven, disillusioned and disaffected of European society who sought a place either to lose, to find or to expand oneself.

Similar phantasms were accorded to the exotic materials, artefacts and 'live' Africans that returning explorers brought back with them to Europe. Much of the plunder from European campaigns in Africa found its way into museums specially designed to accommodate Europe's new scientific approaches to the world and the collection of its objects. The establishment and expansion of ethnographic museums in Berlin, London, Rome, Leipzig and Dresden paralleled Europe's many imperial successes abroad. In 1868, the Berlin Königliche Museum für Völkerkunde was founded; in Paris, the Musée ethnographique des missions scientifiques (the precursor of the Musée du Trocadéro) followed in 1878; and, while the British Museum had been in existence in London since 1753, its collection was significantly expanded during the 1880s. These collections were boosted by private donations from individual expeditioners, by the many artefacts brought to Europe for display in the popular universal and colonial exhibitions of the period, and sometimes by 'booty' seized on punitive expeditions. France's military campaigns in Dahomey reaped the benefits of significant statues and carvings from the royal court of Abomey, later displayed in the Trocadéro museum; and in 1897, museums and private collectors throughout Europe scrambled to purchase more than a thousand bronze plaques and other royal treasures confiscated by the British in an act of reprisal against the *oba* (kings) of Benin.[7]

One of Paris's earliest experiences of live Africans came in a form that promoted these fantasies. Following the whites' conquest of southern Africa, the closing decades of the nineteenth century saw numerous 'philanthropic' impresarios bringing troupes of Zulu and Ashanti tribespeople back to Europe to re-enact key colonial battles for the benefit of Western theatregoers. Jules Chéret's poster promoting one such performance at the famous Folies-Bergère theatre hall in Paris

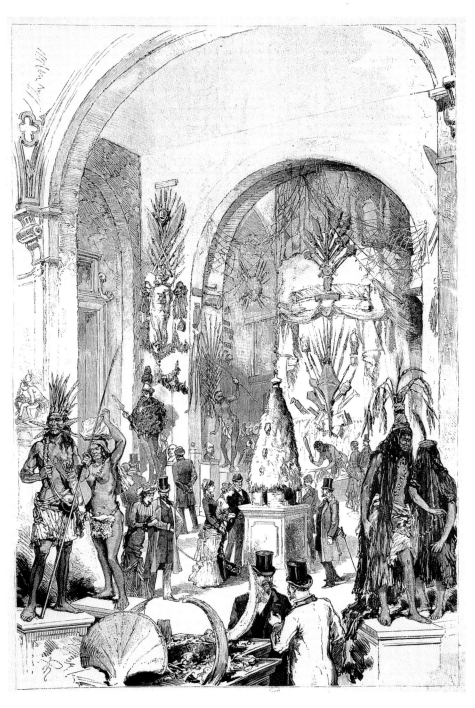

AFTER DE HAENON 'The entrance hall of the Musée ethnographique in Paris', from *Le Monde illustré*, 16 May 1882

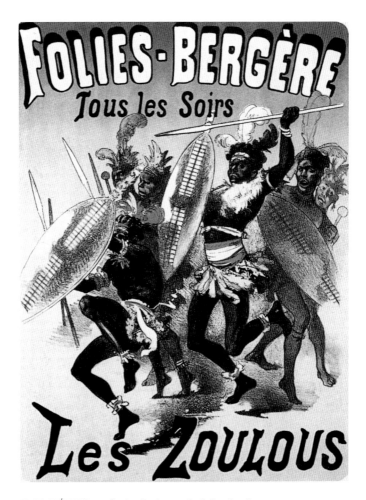

JULES CHÉRET Poster for *Les Zoulous* at the Folies-Bergère, 1878

in 1878 shows a frenzied scene of Africans, replete in costume and carrying shields and spears, conducting a warrior dance. The Dahomeyan Wars in 1892 similarly stirred up French colonial fever. Newspapers and magazines such as *Le Journal illustré*, *Le Tour du monde* and *Le Petit Journal* supplemented their accounts of the French victory over Dahomey with sensational stories of African savagery and cannibalism. Tales of Dahomey became a particularly popular source of Parisian entertainment, as epitomized by another theatrical re-enactment, this time at the Théâtre de la Porte Saint-Martin in 1892. In advertisements for the show, African men and women are shown half naked, hands

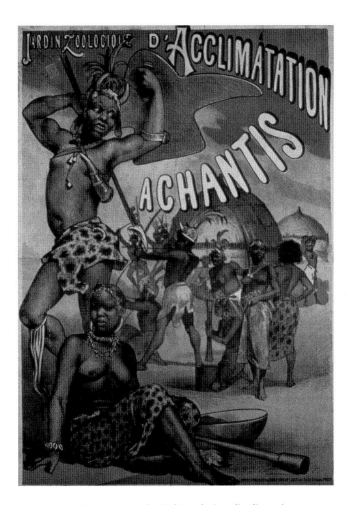

Poster for the Ashanti troupe at the Jardin zoologique d'acclimatation,
Paris, 1895

flaying in the frenzy of battle. By contrast, the French soldiers are shown
fighting back in an orderly and organized fashion, always the disci-
plined victors. These images, and the grotesque tales that accompanied
them, served to divert the public's attention from colonial atrocities in
Africa and to justify French conquests.

In Paris, colonial imagery, academic theory and advertising con-
verged in the ethnographic exhibits and events that celebrated the
French empire. The biggest of these events were the universal exhibi-
tions, initiated in 1855, which strengthened public opinion on France's
colonial destiny. Towards the end of the century, these exhibitions

— Et tu crois que ça nous fait du tort? Tu ne vois donc pas qu'elle a un chapeau de l'année dernière?

Dessin de F. BAC.

F. BAC 'La belle négresse', from *Le Journal amusant*, 1899

became elaborate affairs that vied for popularity with similar events throughout Europe. It was in this atmosphere that the Universal Exhibition of 1889 was held at the Hôtel des Invalides, close to the newly erected Eiffel Tower. Here, a main pavilion surrounded by model huts mimicking villages in Africa and Asia – so-called *villages indigènes* – brought the colonies to life for the Parisian visitors. African sculptures, colonial produce and animals were all displayed as trophies of empire. Entertainment came from Algerian dancers and black soldiers, the latter seen in Paris for the first time. Such spectacle served as colonial propaganda and set a precedent for the exhibitions that followed, such as the Universal Exhibition of 1900, held across the river in the gardens of the Trocadéro, where re-creations of Dahomeyan and Congolese villages, complete with Africans in native dress, added a feel of authenticity.[8]

These colonial exhibitions, world fairs and universal expositions held across Europe, and later throughout the rest of the colonial world, were displays of imperial might designed to mobilize trade and to propagate the message of empire to a much larger and more varied audience.

Annie Coombes, discussing the notion of national and cultural identities, has written that colonial exhibitions and the like were:

> notable for precisely the lack of ... a monolithic structure and an apparent lack of rigorously imposed control over the viewing space. This semblance of endless choice and unrestricted freedom was an important factor in the effectiveness of these exhibitions in obtaining a broad basis of consent for the imperial project. Through the rhetoric of 'learning through pleasure', the exhibitions achieved the sort of popular appeal that the museums dreamed of.[9]

The extensive influence of colonial and scientific thinking in the second half of the nineteenth century is reflected in the advertising of the period. Images of blacks were used regularly to advertise exotic items that came from places considered new, exciting and different, such as the European-owned plantations in the Caribbean. Promoters of rum, tobacco, coffee, cocoa, sugar and spices used the black image to

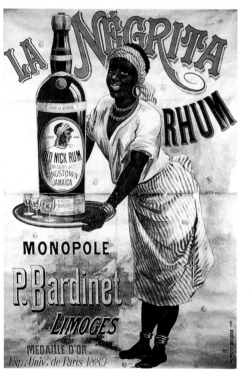

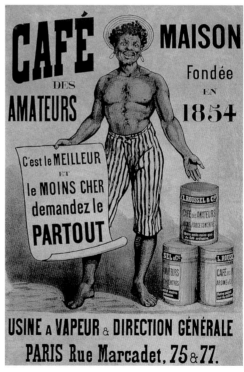

L'IMPRIMERIE CAMIS Advertisement for La Négrita rum, Paris, 1892

ANONYMOUS Advertisement for Café des amateurs coffee, Paris, 1875

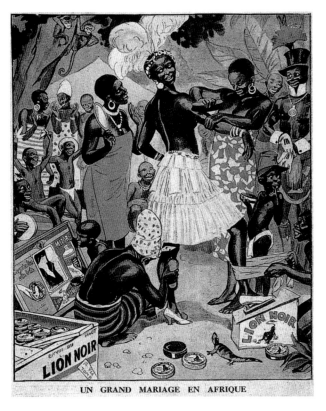

UN GRAND MARIAGE EN AFRIQUE

R. MORITZ Advertisement for Lion noir polish, from *Le Petit Journal*, 27 June 1926

emphasize these products' difference and their newness to the European palate. In such advertisements, Africans and the diaspora blacks of the Americas and the Caribbean were usually depicted differently. Caribbeans, considered more familiar to Europe because of their cultural similarities, shared values and closer colonial contact with whites. Unlike Africans, they were depicted as creolized, with clothes, gestures and settings that suggested their mixed cultural heritage. They also benefited from their close association with the luxury products they represented: there is collusion between their seductive smiles and the packaging of the exotic produce they offer. Additionally, their successful assimilation into ethnically mixed societies is acknowledged by their cheerier dispositions and more colourful garb, and by being set against a backdrop of industry and productivity.

In the twentieth century, advertising for cleaning products such as soaps, toothpastes and polishes reflected Western societies' growing

preoccupation with hygiene and cleanliness.[10] Advertisements for Savonnerie nationale de Genève soap (c.1900), L'Odontophile toothpaste (c.1910) and Lion noir shoe polish (1926) used the negro's blackness as a way of selling the products' particular qualities. The contrast between black skin and white teeth, for example, reinforced L'Odontophile's efficiency as a cleaning agent. In 'Un Grand Mariage en Afrique', an advertisement for Lion noir, the brand name's links with Africa are further stressed by the narrative imagery, where the skin of the bride, Mademoiselle Bamboula, is polished to a high sheen in preparation for her wedding ceremony. Conversely, advertisements like that for Sodex (c.1910) reinforced traditional Christian values related to spiritual cleansing. A boy emerges from a soap-filled tub absolutely white, startling his black female companion: 'washing a nigger white' was the miracle promised by exaggerated advertising.

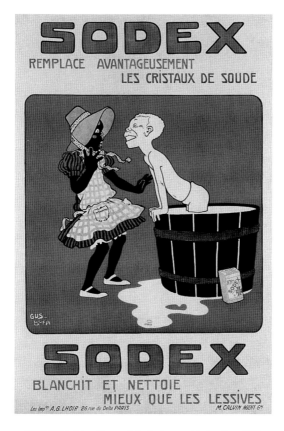

GUS BOFA Advertisement for Sodex washing soda, c.1910

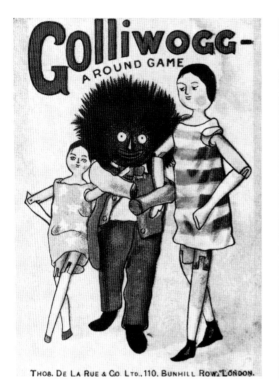

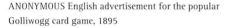

ANONYMOUS English advertisement for the popular
Golliwogg card game, 1895

ACHILLE MAUZAN Italian advertisement for Autolave
washing powder, 1921

That blacks were packaged exotically for the market-place at the
same time that race theories defined them as lesser beings, and colonial-
ism treated them as such, is ironic but also understandable. It was only
by presenting them as different and exotic, by showing them as slaves,
servants, entertainers and humorous characters related to animals, that
their racial inferiority could be communicated. Advertising fed off these
negative depictions, and converted European fears of difference into
'safe' accessible images where whites were given control. For instance, it
made black savagery cuddly in the form of the golliwog, the most
popular black caricature in late-nineteenth-century England; it took
colonialism's slaves and depicted them as willing servants and providers
of luxury, like Sambo, Uncle Remus and Uncle Ben in America; and it
neutered black males' sexuality by representing them as childlike or
effeminate, or as eunuchs of the Turkish harem. Conversely, it enhanced
the black female libido with naked imagery that vacillated between the
French writer Charles Baudelaire's 'Vénus noire' and Aunt Jemima's

generous 'black mama' persona representing abundant nature and the tradition of wet-nursing. Through repetition, advertising reinforced these stereotypes and packaged them for European households.

That Paris should have bought into these stereotypes so readily suggests the city's obsession not only with blacks but also with America at the time. By the turn of the century, New York with its high-rise buildings, subway system and rapidly growing urban beau monde was the epitome of the modern city. Beyond its evident material progress, America also represented a new world in terms of being a model of modern civilization. Like France, it believed in an egalitarian society, and the two countries shared principles that had grown out of their own respective social revolutions. Although cultural exchange between New York and Paris did not reach its high point until after the First World

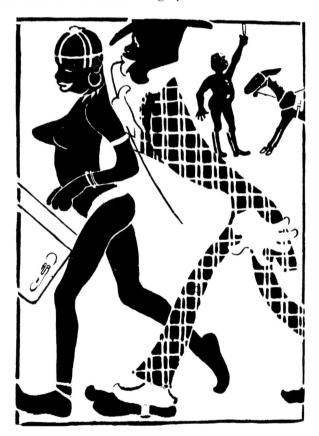

AUGUSTE ROUBILLE 'A negro dandy and an African woman', from *Le Rire*, 6 December 1902

The minstrel performance represents a model case of negrophilia in this period. It provided white audiences with pseudo-black entertainment using white actors; it allowed whites a form of show that vented their ambivalences about themselves, as well as those about the blacks in their midst; and it expressed their mixed feelings about slavery at a time when the abolition debate was at its height. By fashioning themselves as black, whites used the minstrel image to mimic and to mock the negro while reinforcing support for the system of slavery. The minstrel performance also allowed whites to define the negro character in ways that were non-threatening and that afforded engagement with so-called black culture without being intimate with it. The travesty reflected in black-face minstrel performances was merely the grotesque exaggeration of white America's negative self. The strutting, the contortion of bodies, the distortion of lips, the flamboyant speech and the mannered gestures merely projected another, weaker side of the American psyche – one that was safer to package in black skin. Despite the minstrel's black looks, the alter ego that informed them was white at heart.

Numerous French posters demonstrate the popularity of the minstrel shows in France during the 1880s. They also reveal how the minstrel performance was adapted to suit the negrophiliac needs of European audiences. Minstrels, whether black or white, are dressed in Uncle Sam garb, thus defining these characters as black but also American. On the poster for the Brothers Bellonini's performance at the Folies-Bergère in 1885, the brothers are described as 'white-eyed Hottentots', conflating a traditional French characterization of blacks with minstrelsy. Toulouse-Lautrec's lithographs of the African-American circus performer Chocolat, who tap-danced his way to popularity in Paris in the 1880s and '90s, are similar.[13] Although he was not depicted as a minstrel, his name and comic act defined him as black. The cartoon featuring Chocolat reproduced on page 15, with a caption saying that women of ill-repute prefer their chocolate in bed, shows how such buffoonery lent itself to European abuse of black male sexuality.

That the negrophiliac relationship was reciprocated by blacks is evidenced in the forms of entertainment they adopted after emancipation. Locked into their roles as jesters and clowns, they perpetuated white characterizations of themselves by also adopting minstrel roles. In French advertisements for these performances at circuses and burlesque revues, blacks are shown sporting costumes of stars and stripes that identified them with minstrelsy and America's Yankee Doodle Dandy. This parodying of themselves was one of the few forms of entertainment work available to blacks in vaudeville and burlesque theatres. The same

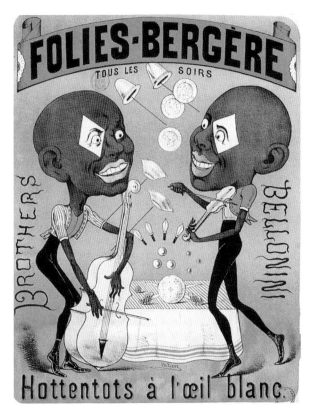

CHARLES LÉVY Poster advertising the Brothers Bellonini's show
Hottentots à l'œil blanc at the Folies-Bergère, 1885

stereotypes would be carried through from the stage into film, as reflected in the titles of early silent movies such as *Wooing and the Wedding of a Coon* (1905), *The Dancing Nig* (1907) and the 'Rastus' series of films (*How Rastus got his Turkey, Rastus' Riotous Ride* and *How Rastus got his Chicken*, c.1910–11).[14] These performances stemmed from a historical imperative whereby blacks learned to perform to white needs in order to survive in white societies. At the same time, it entrenched within blacks a self-loathing and a desire to be the masters of the whites rather than their slaves.

Nowhere is this aspiration more apparent than in the 'cake walk', a dance phenomenon that hit the streets of America and Europe at the turn of the century. The cake walk was rooted in the experiences of plantation life, and was thought to be related to the Christmas-time entertainment when negroes were allowed to strut in front of their

Burns in a world-title fight in 1908 and followed this up with victory over Jim Jefferies in 1910, thus establishing his notoriety throughout the world. Johnson's victories brought a new racial dimension to boxing that helped to promote and revive interest in the sport. In America it aroused the wrath of the white supremacists, who recognized its significance. What was still more infuriating for white Americans was Johnson's cocky attitude inside and outside the ring. Johnson had a penchant for courting white women. His flaunting of unwritten colour codes made his victories over white men both physically and sexually humiliating.

Paris's reception for Johnson was different. Boxing had been introduced to French culture after the 1789 Revolution through an Anglophile sporting society. Despite its English origins, the revival of '*la boxe*', as the French called it, came to Paris via America and was associated with fairground and circus attractions. Blacks who participated in boxing events were fêted for their feats of strength and likened to their African brothers. These 'bad niggers' were greeted with fascination and curiosity. Unlike America, Paris posed no restriction to their fighting with whites, and after 1900 many black boxers gravitated to the city in search of title fights. Johnson came to Paris in 1913 and participated in a number of boxing exhibitions organized by the Nouveau Cirque.

The boxing matches imported into Paris from America carried with them a showmanship and a menacing low life of pimps and prostitution that contrasted sharply with the gentleman's sport that had crossed the Channel from England a century before. Black fights created even more interest because they provided an arena in which the myth of black savagery could be explored and confirmed and even supported. It was boxing's dichotomies that provoked the interest of Paris's extremists, such as the Dada and surrealist groups, who were quick to pick up on the sport's cultural and class contradictions. Boxing's ritualized order meant that it was possible for savage and civilized to meet and to challenge each other on equal terms. It thus offered the possibility to upset the 'natural' order of things.

Dada affiliates courted crassness that cut across mainstream bourgeois values. Roger Lloyd Conover, writing about boxing at this time,[16] quotes a typical Dadaist statement of cynicism from the period that advises those Frenchmen who wished to be American to learn how to box, despise women, chew gum, spit, swear, and pretend to be negro. It is easy to see how the juxtaposition of a black and a white man in the ring fighting for different values appealed to such Dadaists, and how it was perceived as being anarchic and modern. The blackness of boxers like Johnson was also seen as a mark of primitiveness that

Vingtième année. N° **528**. — 15 Mars 1913.

20 centimes.

✦ ✦
UN AN
Paris et Départements, **10** fr.
Étranger, **14** fr.

SIX MOIS
France, 5.50 — Étranger, 7.50

Le Rire

JOURNAL HUMORISTIQUE PARAISSANT LE SAMEDI

✦ ✦
BUREAUX
1, rue de Choiseul
PARIS

Copyright 1913, by LE RIRE, PARIS

✦ ✦

✧ GENTY CONTRE JOHNSON ✧

A Tristan Bernard, boxeur-honoraire.

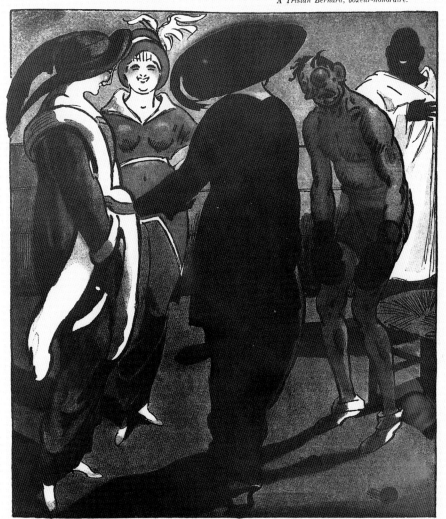

LE VAINCU. — Parbleu ! il a pris une petite chartreuse entre le deuxième et le troisième round ; c'est ce qui a changé la face du combat.

LES PETITES FEMMES. — Et la tienne aussi, mon vieux !

Dessin de MIRANDE.

MIRANDE 'Genty contre Johnson', from *Le Rire*, 15 March 1913

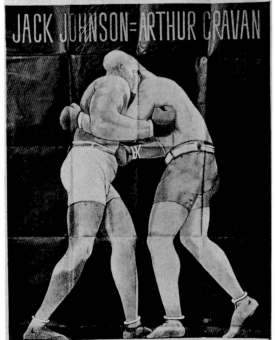

Poster announcing the fight between Jack Johnson and Arthur
Cravan in Madrid, 23 April 1916

authenticated him in Dada circles. Artists such as Peekaboo, Blaise Cendrars, and Sonia and Robert Delaunay gravitated towards Jack Johnson because they identified his outsider status with their own feelings of alienation.

The Dadaists regularly met at the Bal Bullier, a favourite nightspot among artists and boxers. It was most likely here that Johnson first encountered Arthur Cravan, an outrageous poet and Dadaist, and nephew of Oscar Wilde, who promoted his own boxing as a form of art. Cravan's admiration of Johnson is evident from his writings: 'After Poe, Whitman, Emerson, he is the most glorious American. If there is a revolution here I shall fight to have him enthroned King of the United States.'[17] Cravan and Johnson's boxing match in Madrid in 1916 aroused appropriate excitement in both the sporting and the bohemian underworlds. As Conover recounts when discussing the match, both men had been outlawed from their home cultures – Cravan for evading military service, and Johnson for consorting with white women. Cravan was the winner in the ring by a knockout in the sixth round, but both men benefited from the hype and the massive crowd that the fight drew.

Although racial difference provided the visible tensions to Johnson's fights, the invisible political and sexual tensions that his male physicality established in the ring were equally potent. In America, his flamboyant character and transgressive behaviour outside the ring roused white fears of violation and depredation. But in Paris, a city proud of its liberal race policies, the challenge to political and sexual issues was not always so blatant. In the relationship that avant-garde Paris established with blacks at this time, sexuality was implicit rather than explicit. The courtship of blacks by the Parisian avant-garde was an even greater slap in the face of the bourgeoisie and its values than a fist fight in the ring. Johnson was vilified by the mainstream because he challenged its values; he was admired by the avant-garde for the same reason.

In the course of half a century a few blacks like Jack Johnson had come to enjoy a new kind of freedom and even admiration in Paris. As blacks, they believed that the city offered them greater opportunities to realize themselves and their goals. Those blacks who were ambitious did make it. But they would soon discover that the admiration and success they gained from Parisian society came at a cost. The price they paid was their blackness: if they were to advance, they would have to remain minstrels, singing and dancing a white man's tune. They would be expected to bring to life the stereotypes already promoted through advertising.

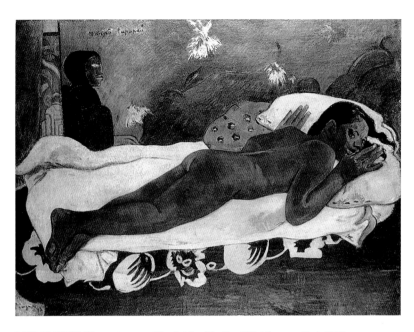

PAUL GAUGUIN *Manao tupapau (The Spirit of the Dead Watches over Her)*, 1892

carvings and idols such as *Manao tupapau (The Spirit of the Dead Watches over Her)* of 1892, combined with myths about Gauguin's own native existence in the islands, cultivated his artistic mystique and influenced the avant-garde, themselves looking for models of the primitive. Superstitions applied to African objects joined with other notions about the occult, theosophy, mysticism, spiritualism, alchemy and magic then popular within avant-garde circles. For example, the *memento mori* themes that initially informed Pablo Picasso's mould-breaking painting *Les Demoiselles d'Avignon* of 1907[3] were quickly usurped by ideas of African idolatry and black magic after his first contact with *l'art nègre*. In Picasso's recollection of confronting African masks in the Trocadéro museum, sixteenth-century superstitions combined with twentieth-century angst and iconoclasm:

> Those masks weren't just pieces of sculpture like the rest, not in the least, they were magic things ... these negroes were intercessors, that's a word I've known in French ever since then. They were against everything, against unknown threatening spirits.... I kept on staring at the fetishes. Then it came to me. I too was against everything ... I too felt that everything was unknown, hostile! The All ...[4]

For many artists like Picasso, works previously seen as products of backward societies were now admired for their conceptual sophistication. The avant-garde considered *l'art nègre* powerful enough to transform and effect profound change, even within the 'civilized' context of Paris. Georges Braque, Picasso's companion painter of the Cubist years and a keen collector of *l'art nègre*, stated: 'The African masks opened a new horizon to me. They made it possible for me to make contact with instinctive things, with inhibited feeling that went against the false [Western] tradition which I hated.'[5]

L'art nègre came to the attention of a handful of artists around 1906 or 1907. Most, like Henri Matisse, André Derain and Maurice de Vlaminck, claimed remarkable experiences similar to Picasso's, and they hotly debated the ownership of *l'art nègre*'s discovery. That African

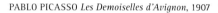

PABLO PICASSO *Les Demoiselles d'Avignon*, 1907

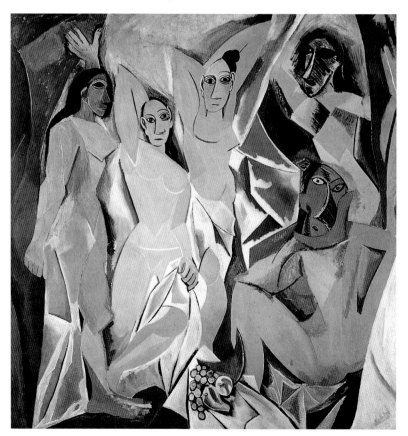

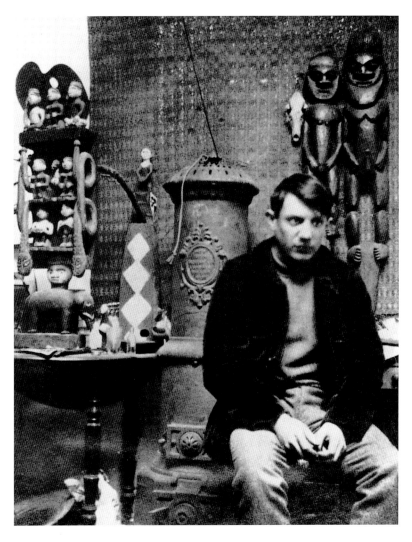

Picasso in his studio in the Bateau-Lavoir, Paris, surrounded by *l'art nègre*, 1908

masks had been in French museums since the previous century, however, made their experiences more encounters than true acts of discovery.

Most artists came across *l'art nègre* in flea markets or via small commercial collectors and traders selling curios and kitsch *objets d'art* made for the European market. Both Picasso's and Matisse's earliest experience of *l'art nègre* was seeing a mask from the shop Au Vieux Rouet, owned by Émile Heymann and situated on the rue de Rennes in Paris,

around 1907. Vlaminck and Derain claimed to have seen works before this in a café in Argenteuil, while *l'art nègre* aficionado Paul Guillaume said that he found his first African sculpture in 1904, in an automobile garage that traded in colonial rubber supplies. Many avant-garde artists would become familiar with the *nègrier* Joseph Brummer, who as early as 1909 opened a small shop on the boulevard Raspail where he also sold curios, *l'art nègre* and paintings by the self-taught painter Henri Rousseau, otherwise known as 'Le Douanier'.[6]

When they began working from these carvings, few artists made a distinction between curios and genuine ethnographic objects. They were more concerned with what *l'art nègre*'s inclusion in a painting signified, than its authenticity. Similarly, few appreciated *l'art nègre* for its aesthetic beauty; instead, its crudeness was valued for its immediacy of expression. Picasso and Brancusi, especially, were drawn to the more grotesque forms of African carvings because of their sharp contrast with European art. Europe's avant-garde absorbed African imagery into Cubism and Expressionism as part of an artistic shorthand that stood for the exotic, authentic and spontaneous – sentiments sympathetic with their anarchic status. As in Picasso's *Les Demoiselles d'Avignon*, Matisse's *Blue Nude: Souvenir of Biskra* (1907) and Braque's *Grand Nu* (1908), even when African forms were not painstakingly represented,

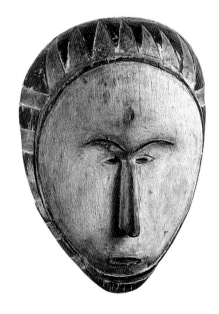

(*above left*) Advertisement for Émile Heymann's curiosity shop Au Vieux Rouet, 1909

(*above right*) Fang mask from Gabon, once owned by Maurice de Vlaminck and André Derain

A short time after we were there
Along came Apollinaire
He sat down on a leather chair
And spoke first of a new art that one day he had implied
To be a sort of 'technepheism'
To use a simple term
Which an American had made
A photo had been taken
Between May and October
Of the first *plâtre à toucher*
Apollinaire descanted afterwards
On poetry not the poets
And the new passionate man
He revealed to us the secrets of the gods who theed and thoud him
So that now none of us who were there listening
Have the right anymore to say
What's the poem all about I didn't understand a thing
And then we had some Debussy
You see
The poets X Y and Z
And the profound *Aujourd'hui*
By Monsieur Blaise Cendrars
What the author of *Henriette Sauret* was thinking
I'll tell you when I find out
And then we heard three interludes set to music
Comic by Auric
And sung by Berin
These three little pieces were very much liked
And they ran along nicely right to the end
And then and then we had Erik Satie
Who paraded and disappeared
And Lara who had appeared.

Ironically, the dislocation caused by the war stimulated such exchanges, and these *soirées* were crucial to the movement of ideas from one Dada camp to another in Paris, New York and Zurich.[9] Dada itself had been grounded in 'performance', and it was its openness to all forms of expression that assisted the cross-fertilization of ideas that was characteristic of the period. Significantly, black culture was a common factor among these ideas. Not black culture in and for itself, but black culture as an interlude to modernity. The rhythms of Debussy, Satie and Auric;

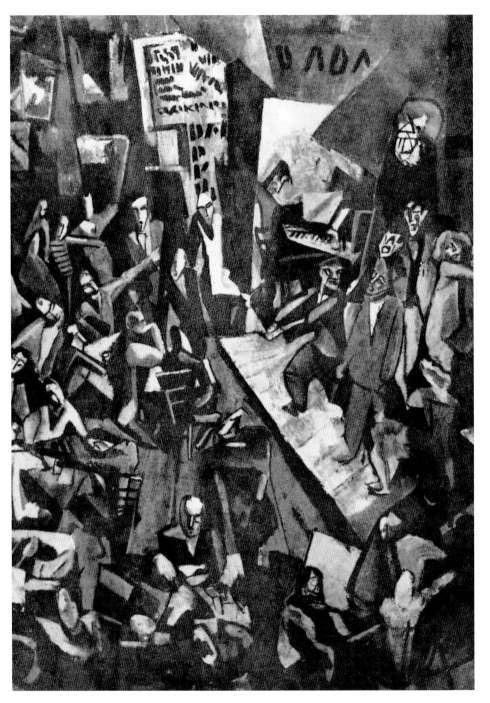

MARCEL JANCO *Cabaret Voltaire*, 1916

the poetry of Blaise Cendrars and Tristan Tzara; the lectures of Guillaume Apollinaire on the 'new passionate man'; and the interchange of ideas in this period between artists such as Francis Picabia, Marcel Duchamp and Robert and Sonia Delaunay – all demonstrate the avant-garde's indebtedness to black music, masks and mythology.

A more studied approach to art from Africa gradually emerged in the postwar years. Its legitimization came out of a mutual exchange of ideas and activities between ethnographers and artists. An interdisciplinary network of thinkers involved in the study and promotion of primitive art and cultures developed between Europe and North America, with aestheticians like Henri Clouzot and André Level in Paris, Carl Einstein and Max von Sydow in Germany, Roger Fry in London and Marius de Zayas in New York all participating. Academic theories about origin, evolution, function and meaning merged with Dadaist, surrealist and other avant-garde thinking which promoted the primitive as central to modern life. Several publications, such as Carl Einstein's *Negerplastik*,[10] Paul Guillaume and Guillaume Apollinaire's *Sculptures nègres*,[11] Henri Clouzot and André Level's *L'Art nègre et l'art océanien*[12] and the journals *Les Arts à Paris* and *Cahiers d'art*, brought a new conscientiousness to the study of African art. Artists and ethnographers worked together to display *l'art nègre* better. In Germany, the ethnologist Carl Einstein collaborated with the collector Daniel Kahnweiler on *Negerplastik*; in England, Roger Fry, author of *Vision and Design*,[13] kept close contact with the sculptors Henry Moore and Jacob Epstein; in New York, Marius de Zayas exhibited works of Dadaist and surrealist artists alongside tribal sculptures;[14] while in France, the dissident surrealists Georges Bataille and Michel Leiris attended the lectures of the ethnologist Marcel Mauss, and later assisted in the reorganization of the Trocadéro under the supervision of the ethnographers Georges-Henri Rivière and Paul Rivet.[15] These collaborations also gave rise to a new kind of writing about African art, and also a new breed of collector considered African-art connoisseur.[16] Chief among this group of specialists were the poet and critic Guillaume Apollinaire and his friend Paul Guillaume, founder of *Les Arts à Paris*.

Guillaume Apollinaire was one of the first people to study *l'art nègre* seriously using a combination of ethnography and art history, and he subsequently became a leading champion of the art among the Parisian avant-garde. It was he who first promoted its perceived primitive qualities as modern, and he who advocated its acceptance in the French national collections at the Louvre. Unfortunately, Apollinaire's own reputation as a reckless poet, as a central figure of Montmartre's bohemian

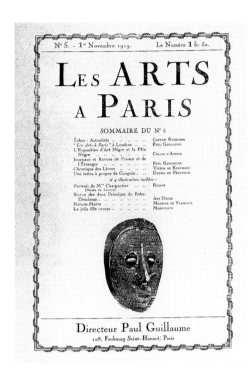

Cover of Guillaume's *Les Arts à Paris*, 1 November 1919

set, and as a somewhat boisterous and vocal immigrant did little to enhance *l'art nègre*'s mainstream status. His legacy to African art is that, as a precursor of surrealist thinking, he ensured it became part of that group's subversive agenda.[17]

Paul Guillaume was still a young man when he began to make a name for himself as a specialist in the field of *l'art nègre*. By 1911, when he was just twenty years old, he was a regular with the Montparnasse group of bohemian artists and writers, keeping company especially with Chaïm Soutine, Giorgio de Chirico and Amedeo Modigliani, and he had already started selling African sculpture. It was in this same period that he met Apollinaire. The two men developed a deep respect for each other based on their mutual love of *l'art nègre*. In 1916, when Guillaume presented the first public exhibition of negro art in Paris, it was Apollinaire whom he approached to write an article promoting the work. And when Guillaume created *Les Arts à Paris* in 1918, Apollinaire became the journal's main contributor.[18]

Les Arts à Paris was a tasteful review of Paris's modern-art world interspersed with articles about art from other cultures. Its presentation

of *l'art nègre* fused artistic appreciation for the exotic qualities of the art with the more aestheticized and academic approach of ethnography and connoisseurship. Given Apollinaire's Dada tendencies, the journal was surprisingly subdued, possibly more reflective of Guillaume's conservative tastes. It had none of the angst-ridden photomontages, crude photography and startling juxtapositions that would become particularly characteristic of *l'art nègre* presentations in many later surrealist journals.

The forms of *l'art nègre* that Guillaume and Apollinaire favoured can be seen in the pages of *Les Arts à Paris*, as well as in those of Guillaume's later book *Primitive Negro Sculpture* (1926). They show some of the finest pieces of art from Africa then available in Paris. Most were from the private collections of men like Guillaume, the fashion mogul Jacques Doucet, the modern-art collector Léonce Rosenberg and the ethnographer André Level. Most pieces became familiar to the art world's *cognoscenti*, who were used to seeing them exhibited alongside modern art. Fang masks from West Africa were popular, as were the polished Baule heads from Gabon. In *Les Arts à Paris*, these were photographed, labelled and documented in a way that demonstrated Guillaume's treatment of them as equal to modern art. This aestheticized approach neutralized their perceived potency in favour of what Guillaume called, 'the plastic qualities of the figure – their effects of line, plane, mass and colour – apart from all associated facts'.

The third issue of *Les Arts à Paris* in December 1918 announced the death of Apollinaire a month earlier, describing him as the 'genius of that era'.[19] His death at the end of the First World War also seemed to mark the passing of an era of angst and wartime hysteria, characterized by his own interests in Dada. With Apollinaire's death, Paul Guillaume became the principal advocate of *l'art nègre* in Paris, a role he seems to have relished. Like Tristan Tzara, he promoted his own *soirées* introducing black themes. The most important of these evenings was a 'Fête nègre' at the Théâtre des Champs-Elysées in 1919, held in conjunction with the exhibition 'Première Exposition d'art nègre et d'art océanien' at Guillaume's Galerie Devambez.[20] The 'Fête' featured modern music and dancing based on African mythology, a precursor to *The Creation of the World* performed by the Ballets Suédois four years later (*see chapter 4*). Guillaume's own African-styled gyrations at such evenings, and his belief that the the negro represented 'the new intelligence of modern man', earned him the title '*négrier*' from Jean Cocteau, and he would later be described by the American collector Albert C. Barnes as 'the man who saved negro art'.

Albert C. Barnes, one of the leading early American collectors of modern art and *l'art nègre*

The continued regular featuring of the 'negro-American' in Guillaume's *Les Arts à Paris* was undoubtedly related to his links with Barnes and Thomas Munro of the Barnes Foundation in Merion, Pennsylvania. Guillaume's relationship with these two American intellectuals represented the cosmopolitan aspect of the journal and afforded him access to a source of lucrative funding, as well as providing *entrées* to a fashionable American circle with its own academic pretensions. In the 1920s, Guillaume cultivated these friendships, acting as a dealer for Barnes, purchasing both *l'art moderne* and *l'art négre* for the Barnes Foundation.[21]

It was through this international partnership that *Les Arts à Paris* sporadically published articles about contemporary black culture, in particular about the Harlem Renaissance. During the early 1920s, Alain Locke, author of *The New Negro* (1925), Jamaican writer Claude McKay and the African-American writer Langston Hughes, key figures in the Harlem Renaissance who were then trying to establish careers in Paris, were all introduced to Guillaume, Barnes and Munro. Through Barnes, Guillaume also wrote about art events in Paris, thereby opening up a dialogue about *l'art nègre* that spanned the two continents.[22]

The image of an ailing art form was an important metaphor for Guillaume, one that he took beyond the arts into a more general critique of Western society. For him, European society was intellectually and artistically drained and in need of salvation. To overcome Europe's 'anaemia', he felt that 'negro art' had a spiritual mission to develop the taste of the twentieth century: 'The spirit of modern man – or of modern woman – needs to be nourished by the civilization of the negro.'[23]

In his address to the Barnes Foundation in 1926, Guillaume professed his unreserved admiration and passionate missionary fervour for *l'art nègre*. He enthused:

> The modern movement in art gets its inspiration undoubtedly from African art, and it could not be otherwise ... since Impressionism, no primordial manifestation could be shown that is not African in essence. The work of the young painters such as Picasso, Modigliani, Soutine, for example, is to an extent the work of African emotion in a new setting. In the same way, the sculpture of Archipenko, Lipschitz and Epstein is impregnated with Africanism. The music of Bernard, Satie, Poulenc, Auric, Honneger – in short all that is interesting since Debussy – is African.[24]

For Guillaume, salvation for both black and white cultures was the responsibility of this avant-garde, which he described as 'we, modern knight errants'.[25]

By the late 1920s, Guillaume had become a respected connoisseur of African art, far removed from the idealistic young man who had demonstrated an African ritual dance at his 'Fête nègre' just a few years previously. As with Picasso, Guillaume's shift from far left to centre was a natural consequence of his relinquishing youth's bohemian lifestyle in favour of stability, respectability and the enjoyment of new wealth. The postwar boom, *Les Arts à Paris* and a new gallery in a prestigious area of Paris also helped to establish Guillaume's new status as African-art connoisseur. His lifestyle included a stunning wife, an automobile with black chauffeur, summers in the country, and a Paris home near the avenue Foch. Guillaume had exchanged avant-garde idealism for the safe haven of art-dealing.[26]

The end of the First World War had brought a respite from battle that allowed Paris to savour its new material comforts: electricity, the telephone and motorized transport. The excitement of modern and technological innovations enticed some members of the avant-garde, and they cultivated a lifestyle that embraced both an idealized primitive past and a modernist

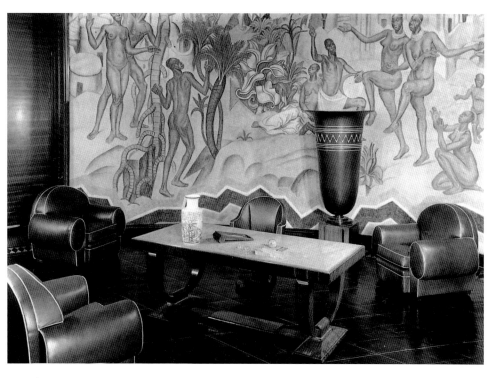

ÉMILE-JACQUES RUHLMANN '*Africaniste*' study designed for Paul Raynaud, Minister of the Colonies, now in the Musée des Arts de l'Afrique et d'Océanie, Paris

'*esprit nouveau*' future. In the same way that some modern painters and their paintings leaned towards postwar conservatism, so *l'art nègre*, originally sought out for its anti-establishment stature, was now paralleled with a stylized *africanisme* born out of colonialism. This 'African aesthetic' was a state-supported style that related more to the postwar *rappel à l'ordre* (call to order) and conformity of Jean Cocteau than the audacious ideas and pell-mell interests of the late Guillaume Apollinaire.

Not everyone in the Parisian art world welcomed the discord of Dada. The courting of Dadaist sentiments alongside a predilection for *l'art nègre* ran counter to the more mainstream desire for the ideological *rappel à l'ordre* encouraged by Jean Cocteau and his circle.[27] By the end of the war, the French were antipathetic towards their 'Gothic' German neighbours; similar differences developed in artistic circles. The call to conformity was nationalistic and represented an emphasis on the rational over the emotional; it directed vanguard taste towards classicism by stressing French culture's Latin roots. In painting, this manifested itself

in what André Salmon, the art critic and close friend of Picasso, called '*la tradition française*', a sentiment that reflected a preoccupation with orderly balanced compositions and classical forms. Salmon reconstructed French art history, emphasizing its classical tradition and Latin origins, but he also saw that tradition as being eclectic enough to accommodate artists of different nationalities with different styles. The crucial factor for their inclusion was, somewhat paradoxically, both their contribution to tradition and their artistic innovation. But Salmon's interpretation of French tradition also suggested a compromise of the more primitive aspects of avant-garde practice. Picasso, in particular, indulged in this imagery, transforming his disruptive confrontational Amazonian-type women who had dominated his Cubist paintings into maternal figures who were essentially images of fecundity, stability and continuity symbolic of postwar reconstruction. These colossal women were placed within Arcadian settings as Demeters: they were the classical counterparts of their primitive sisters. In music, simple, refined compositions like those of Erik Satie were favoured as 'French' over arrangements that relied too heavily on foreign rhythms like ragtime and jazz. Similar temperance towards foreign forms was seen in the 'colonial style' that dominated official salons and the homes of the wealthy, such as the study designed by Émile-Jacques Ruhlmann for Paul Raynaud, Minister of the Colonies (*see page 65*). This style, whether for furnishings or accessories, was grand in scale, with bulbous forms, generous proportions and rich and refined surfaces with restrained references to *l'art nègre* and the 'Orient'. It was a style that suggested power, dominance and authority.[28]

The postwar period, then, was one of spiritual, stylistic and ideological ambivalence. And responses to *l'art nègre* fell between these stools. In conservative camps, it was absorbed into a grander aesthetic that represented colonial triumph and French imperialism, while for the avant-garde it was a cruel tool used *épater les bourgeois*, to shock middle-class sensibilities. These differences were also seen in Parisian social circles. The fashions created by designers such as Jacques Doucet, Paul Poiret and Jeanne Lanvin were designed for a staid *haute bourgeoisie* that rarely mingled with the avant-garde. Its tastes were cultivated by travel and supported by colonial wealth. It enjoyed a lifestyle of opulence and quiet money. Its social calender was hectic and included viewing the *haute couture* collections in the spring; visiting Riviera resorts, the races, and golf and tennis tournaments in the summer; hunting at country homes in the autumn; and attending more fashion collections and parties in the winter. Their contact with the avant-garde was limited to patronage

of exhibitions and theatre productions, as well as occasional visits to restaurants and nightclubs in Montparnasse and Montmartre as 'slumming' became a popular pastime with the younger set.

In an era increasingly seduced by spectacle, the theatre and other performance arts became the media through which vanguard activities were introduced to this élite public. In the postwar period, two ballet companies emerged as stylistic opponents: Dhiaghilev's Ballets Russes, which enjoyed wealthy patrons and the support of Cocteau, Picasso and his circle, and the Ballets Suédois, which attracted artists such as the Delaunays, Fernand Léger and Blaise Cendrars (*see chapter 4*). The rivalry between the two companies centred around stylistic forms in the music, choreography and visual aspects of their stage sets and performances. Predictably, the Ballets Russes favoured a modernism harmonized with folk and classical forms, while the Ballets Suédois courted a modernism shot through with contemporary references in which black culture was an important source. *L'art nègre* was popular with both sets, distinguished only by their different attitudes.

L'art nègre's initial introduction to interior design was linked to colonial conquest, and was directly related to the taste of Paris's wealthy élites. It was the preserve of expeditioners and collectors who acquired African objects as trophies of their travels. The home of Georges-Marie Haardt, organizer of the 1925 'La Croisière noire' expedition across Africa, which was featured in *Vogue* after his return, typified this colonial style.[29]

'La Croisière noire' was the second in a series of expeditions across Africa sponsored by the French car manufacturer André Citroën.[30] The expeditions were designed to expand colonial communications and to promote French manufacturing in Africa. Like modern-day versions of the eighteenth-century explorations of Africa, both of these 'missions', under the direction of Haardt and Louis Audouin-Dubreuil, witnessed the first 'penetrations' of the African hinterland by Citroën automobiles. The original expedition, from Algeria to Timbuctoo, had taken place in 1923, and, because of its success, the second, more ambitious trip was organized two years later.

The 1925 'La Croisière noire' expedition was afforded Hollywood-style treatment even in its planning stages. At a time when advertising was becoming increasingly sophisticated, the 'mission' became a grand promotional exercise involving the complete documentation of the journey, regular coverage in the French press, and a multitude of commercial ventures geared to exploiting the African adventure. The potential of cinematography was not lost on the mission's promoters, and the new film media was used to verify its scientific nature, as well

This collection of *objets d'art* and its placement within the African-styled setting of Haardt's salon offer a microcosm for understanding the workings of the colonial mentality, its exploitation of trade and commerce in Africa, and the process of vulgarization and packaging of 'things African' once returned to Paris. The room is the product of colonial conquest, and an examination of the artefacts that contribute so much to its style demonstrates how France's colonial policy of appropriation worked. For example, the painting that hangs on the wall of the salon appears to be a fairly innocuous if not flattering homage to African women. Entitled *Daba, femme Soma*, it is one of several portraits by Iacovleff depicting the peoples encountered by the 'La Croisière noire' team.[31] The subject is presented in four poses characteristic of serious ethnographic studies at that time. But there is little that is scientific about Iacovleff's composition. He chose as his subjects young female forms that were distinguished by their long lean physiognomy. To accentuate this feature, he squeezed them into narrow compositional formats and rejected the use of formal perspective. He placed them at various distances within the picture plane, standing, kneeling and squatting. The effect was to exaggerate their height, making them appear as statuesque females who dominate the landscape. In the horizonless background, these women appear like goddesses on a mountain top, where they preen themselves to the delight of the voyeur. The real context for this picture, however, appears to have been a beauty competition arranged by the expedition team for their own titillation. Photographs in Haardt's private album show that these naked women were part of a line-up presented to the cigar-smoking jury of male expeditioners when they visited Fort Archambault. Iacovleff's paintings package the winner and runners-up in an idyllic setting that denies the vulgarity of the composition's origins.[32]

Similar concerns apply to the expedition's treatment and documentation of the Mangbetou tribe, members of which became the mascots of the expedition. Located in the Congo region of central Africa, the Mangbetou were a curiosity for the 'La Croisière noire' team. Their refined features, sense of physical grace, rich culture and complex political structure challenged European preconceptions about the 'primitive' state of African civilization. Further, their elongated skulls, a result of ritual head-wrapping, combined with their long necks and proud posture, gave the tribe an unusually regal appearance.

But the idea that a black state could be as 'advanced' as the Mangbetou clearly were was anathema to the colonialist mentality. Rather than accommodate the tribe within an African tradition, ethnographers of the period postulated that it was a displaced Egyptian race,

thereby locating it within an orientalized North African tradition, one that already had a place within the Western schema of art history. To this end, Iacovleff depicted Mangbetou women in profile, demonstrating their physical distinctiveness and 'deformation' (as these colonials termed it), and promoting visual parallels with Egyptian figure painting. Similarly, photographs show how the Mangbetou were posed to exaggerate their physiognomy to best advantage, to create parallels between popular images of Egyptians, and to 'hype' the Mangbetou as a lost tribe discovered by the expedition.[33] During the next decades, *la femme mangbetou* would be restyled and repackaged to promote an assortment of events, goods and services in Paris, including the Pavillon des Tabacs at the colonial exhibition in 1931. Her image became synonymous with Baudelaire's *Vénus noire*, and iconic of white male fantasies about black women.

Colonially styled rooms like Haardt's, or the powerful interior furnishings of designers such as Ruhlmann, found greatest favour with a 'chic bourgeoisie' eager to establish new trends in fashion. Few were adventurous or privileged enough to outfit their homes with authentic *l'art nègre* in the manner of Haardt. Instead, they commissioned skilled artisans and designers to reproduce or to adapt African designs in their work to suit individual taste. It is against the background of this conservative, élite appropriation of African forms that the trend towards a more popular, manufactured 'black deco' style must be viewed.[34]

As coined by Rosalind Krauss, the term 'black deco' represents the stylizing attitude that allowed for a playful recombination and transmutation of *l'art nègre* into modern art. But the same term can perhaps also be used to suggest *l'art nègre*'s influence on popular decorative arts, where a similar playfulness further enhanced the modernist Art Deco. An exhausted Western art, and its overburdened system of state patronage, predisposed the twentieth-century avant-garde artist and designer to alternative art forms. In the 1920s, this trend filtered through to the market-place and the production of 'kitsch' products. *L'art nègre*'s absorption into popular taste was part of this 'trickling down' as the ideas of the avant-garde were commodified and repackaged, firstly by skilled designers and craftsmen such as Pierre Legrain and Gustav Miklos, and secondly by a growing manufacturing industry eager to co-opt African art into a marketable form of Art Deco. As we will see, *l'art nègre*'s influence was seen in Art Deco's imitation of black forms and in its surface designs and finish, but also in the *frisson* of exoticism and excitement that it brought to mass-produced items. The negro form, taken from the marginal area of painting to the sphere of design, quickly influenced commissioned furniture, home interiors, architecture, clothes and jewelry.

Sonia Delaunay's 'jazz' textile and fashion designs anticipated this trend. On returning to Paris from Spain after the war, Delaunay became something of a muse for the poets and writers of her circle, and was revered for the retention of folk patterns in her work and its primitive qualities. She quickly established friendships with the surrealist poets André Breton, Louis Aragon, Philippe Soupault, René Crevel, Robert Desnos, Jacques Baron, Vincente Huidobro, Yvan and Claire Goll, Iliazd (Ilia Zdanevitch) and Tristan Tzara. This period witnessed a number of collaborative projects, including Tzara's 'poem dresses' fashioned from Blaise Cendrars's sensuous poem 'On her dress she wears a body', which was dedicated to Delaunay.[35]

In the postwar period, Sonia Delaunay's work – up to that point, closely associated with the simultanist paintings of her husband Robert Delaunay – achieved greater stylistic individuality because of her concentration on fabric and costume design for the theatre and fashion worlds. Her independent status as a designer benefited from the popularity of printed fabric, which after the war provided an alternative to the woven silks and woollen textiles that had previously been the mainstay of the clothing industry. Printing on fabric was new. It was also cheap, since it required materials such as cotton, previously considered an inferior fibre. Moreover, printed cotton allowed for greater intensity of colour and expression, and thus for more elaborate costume designs. Sonia Delaunay, who dressed herself like a theatre model, attracted attention to her gregarious designs merely by wearing them.

Between 1923 and 1925, Delaunay was to develop fabrics that on initial examination appear to be self-inspired in their purity of design. Their patterns come together out of a compression and repetition of the rhythms she had explored in her earlier costumes. They were bold expressions, geometric designs in several colours that must have stunned the eye of the Parisian onlooker. These fabrics took the colour dissonances, intensities and geometric consistency previously evidenced in simultanist painting to the extreme. The designs were an uncompromising resolution of those painted surfaces. One critic wrote: 'Finally, after all those foreign influences, after all those orgies of oriental color which the first Ballets Russes brought to France, we have reached, in the field of fabrics, an art that is both modern and intrinsically French.'[36]

Yet that French modernity still had a debt to pay to black culture. Delaunay's work was the visual counterpart of the modern music of Darius Milhaud and Francis Poulenc, which drew heavily on African-American rhythms. While it is true that her textile designs had a sense of rhythm that was derived from an awareness of modernity and con-

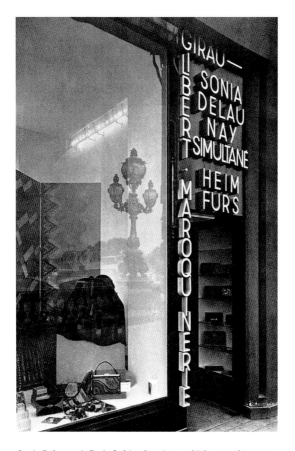

Sonia Delaunay's Paris fashion boutique, which opened in 1925

temporary popular music, and that descriptions of her work as display-
ing 'the rhythmic aspect of colour' or 'vibrations and undulations'
should be placed within the context of jazz, swing, flamenco and tango
music, they must also be viewed in relation to Africa and its perceived
'vitality'. All these vulgarized forms Jean Cocteau labelled as 'worth-
less bric-à-brac'.

Placed alongside African fabrics, Delaunay's textiles are similar,
but not derivative. Delaunay used visual principles informed by the
'rhythm' of her time rather than mere mimicry. It is difficult to pinpoint
exactly when black forms became a distinctive source of reference in her
work, but from her display at the Exposition internationale des arts
décoratifs in 1925, it is clear that Delaunay had started to be influenced
by that time. Previously, her sources appear to have been more aural

than visual, and more conceptual than formal. The success that greeted her 1925 designs shows the extent to which they were a response to the needs of popular taste. Her designs had entered a market that was already responding to jazz and black culture, one that was keen to acquire products that were signifiers of that culture.

Sonia Delaunay's designs were the precursors of the 'black deco' forms that gave a frivolous edge to the state-supported style of Art Deco, which made its first 'official' appearance at the Exposition internationale des arts décoratifs of 1925. There, *l'art nègre* had been introduced in decorative touches to the aspiring French modernist style. This bastardized form of Art Deco was a vehicle for fantasy and self-fulfilment at a deeply emotional level, first discussed by Paul Guillaume, holding far more appeal with the artistic vanguard than the austere message of 'empire-building' communicated through examples of the establishment's colonial art and design, such as Haardt's salon. 'Black deco' was the manufacturers' answer to these avant-garde ideas, as well as being a way that aspects of *l'art nègre* were first packaged by Europeans for Europeans. But it was also, as Rosalind Krauss has suggested, a soft packaging that was formulaic and 'gutless'. It is within this context that the sitting room of Jacques Doucet must be considered.

The room that Doucet commissioned from interior designer Pierre Legrain for his Neuilly apartment was designed to look African but contained little authentic *l'art nègre*. The antimacassar and rug were reproductions; the furnishings, worked from genuine designs, were also copies. Hanging above the sofa, Henri Rousseau's junglescape *La Charmeuse de serpent*, lush, ordered and idealized, dominated the room's primitive coding. The other paintings on the wall completed the ensemble, co-opting the room's Africanicity into an exotic modernist 'black deco' aesthetic closer in spirit to Art Deco than the colonial style of designers like Ruhlmann.

> The problem was to create a harmonious atmosphere around the already rich collections, where placed side by side were the works of Iribe, Groult, Coard, Modigliani, Matisse, Picasso, Miró, Picabia and those sculptures or masks that were to have a profound influence on contemporary art.[37]

To this end, Doucet's collection of fine furniture reflected the work of a number of skilled artists and designers, including not only Legrain, but also Joseph Csaky, Gustav Miklos and Jean Lambert-Rucki, each of whom developed independent styles indebted to *l'art nègre*. Doucet's influence was seminal. It was through his commissions that these

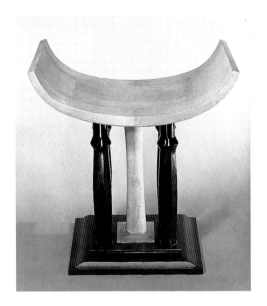

PIERRE LEGRAIN Stool in black lacquer and shark skin over wood, designed for Jacques Doucet, c.1923

PIERRE LEGRAIN Chair in brown lacquer and decorated with incised-gold triangular motifs, designed for Jacques Doucet, 1923

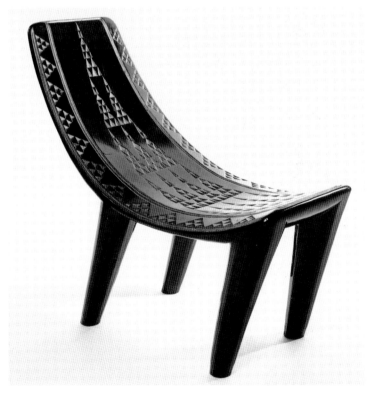

craftsmen got their first exposure to *l'art nègre*. Doucet had originally been a collector of antique furniture and paintings. In 1912, inspired by modernist movements such as post-Impressionism and Cubism, he auctioned his collections and, at the age of sixty, began to collect the work of painters like Picasso as well as *l'art nègre*.[38] He aimed to bring all of these styles together in his new apartment, working with renowned Art Deco designers such as Eileen Gray, Rose Adler, Marcel Coard and René Lalique. His specific requirements often necessitated the collaboration of two artists for one piece (one for the making, the other for the decoration), resulting in items which were a controlled balance of authentic African and modern Art Deco principles. The two pieces from Doucet's collection shown on page 75, both created for his Neuilly apartment by Pierre Legrain, met the client's exacting demands, while also reflecting the designer's own predilections.[39]

Legrain's designs are solid and geometric, displaying their indebtedness to a Cubist severity. Yet, what lightens their surfaces are the African forms and precious-metal inlays also evident in Legrain's book designs. Legrain's principles were rooted in Cubism, characterized by his use of contrasting materials and what Philip Garner describes as a flair 'for exploiting the visual and tactile qualities of the most unusual materials, often in incongruous relationships with one another'.[40] Hence, we see the constant use of gloss surfaces, whether lacquer, enamel or chromed metal, paired with heavily grained woods such as palm and palisander, exotic fabrics and animal skins. These juxtapositions stem from Cubist collage, but they also reflect an understanding of the mixture of materials found in some African art. Legrain's designs also echoed the influence of Egyptian art's luxurious finishes and the 'found object' of untold wealth. This *mélange* as applied to *objets d'art* and furniture – rough with smooth, matt with sheen, stark with embellished – resulted in a product considered more whole because of its material complexity: a mixture of the primitivized and the modern. Examination of the work of designers such as Miklos, Legrain, Lambert-Rucki and, to a more limited extent, Csaky shows how their hybrid designs bridged the worlds of modern sculpture and modern design. They also straddled the postwar divide between French-born and immigrant artists. The market in handcrafted items of furniture and *objets d'art* provided a niche for immigrant artisans who shunned France's hierarchical salon traditions.

Art historian Thomas Crow, looking at the relationship between the avant-garde and mass production, rightly sees the role of artisans and craftsmen as integral to the process of popularizing and packaging avant-

garde styles for a wider market.[41] His example of Art Deco in the 1920s can comfortably be extended to accommodate the influence of *l'art nègre*. For Crow, it is through the efforts of artisan-level entrepreneurs that:

> a wider circle of consumers gains access to an alluring subcultural pose, but in a more detached and shallow form as the elements of original style are removed from the context of subtle ritual that had first informed them. At this point, it appears to the large fashion and entertainment concerns as a promising trend. Components of an already diluted stylistic complex are selected out, adapted to the demands of mass manufacture, and pushed to the last job lot and bargain counter.

This was especially the case with the fashion industry, which picked up on *l'art nègre* innovations for the clothes, shoes and accessories it presented at the 1925 Exposition internationale des arts décoratifs. Once married with Art Deco, *l'art nègre*'s references in fashion were subtle but still significant. The style encouraged the use of black and white as a colour combination, the wearing of headwraps and turbans, and the popularity of the ostrich feather, hanging earrings, chokers, pendants and bangles. Fabric design also registered the trend, mirroring the Cubist paintings of a decade earlier, with greater emphasis on the linear than the cuboid, and with colour aligned to the syncopated rhythms of the jazz age.

JEAN DUNAND Neck-rings decorated with
lacquered geometric motifs, 1927

As with furniture, mixtures of different materials distinguished the fashion of the 1920s, with an emphasis on exotic animal skins. The catalogue for the 1925 exhibition described the range of skins from all over the world that had previously been despised by the elegant but that were now in fashion. Included were skunk, monkey, antelope and mole, in addition to the more popular kid skins of panthers, seals and leopards. Although far from being environmentally friendly, these skins were seen as bringing one closer to nature and the primitive. The availability of these skins was also a spin-off of colonial conquest and a mark of Western man's dominion over his environment.[42]

A new crop of fashion magazines, including *La Gazette du bon ton, Art, goût, beauté, Jardin des modes* and *Vogue*, as well as the growing influence of film, popularized the use of *l'art nègre* in clothes design. At the same time, fashion illustration became a genre in itself. The fashion scene, previously dominated by Art Nouveau-inspired designs of mainstream fashion designers like Paul Poiret, now incorporated Art Deco's minimalism, bold stencil hand colouring, jazzy patterns and mixed textures.[43] These designs were carried through to the detailing of accessories: gloves, cigarette cases, purses, compacts – all bore reference to African decoration. By the end of the 1920s, this style was popular enough to be translated into mass production, particularly with the growing influence of plastics, enamels and gilded metals.

But what was this packaged style, and what was the essence of this trade? Effectively, to purchase one of these items was to buy oneself 'authenticity', and to identify oneself with a primeval past. It was an idea packaged from the outside in. Surface design and exterior packaging implied similar content inside. Worn like fetishes, accessories such as Piver's perfume Fétiche allowed the wearer to assume the qualities of the product. The inherent references were to the savage or barbaric persona, to sexual attractiveness and eroticism, to excitement and exoticism. These products were worn by Westerners as vibrant accessories to their jaded psychic wardrobes.

Africa's allure for Paris was that it stood for a spiritual life obscured from societies that had become 'civilized' and mechanized through material development. For all its sophistication, Parisian society's yearning for ritual and participation in a collective identity made it susceptible to any new fad that promised spiritual stimulation. Urban living, with its emotional and spiritual dependence on a 'kitsch' cultural commodity market, craved the products of the avant-garde which traded and diluted *l'art nègre*'s style.

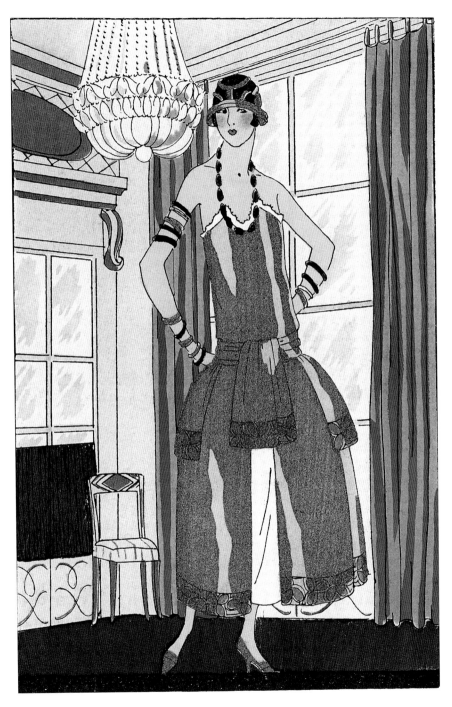

PAUL POIRET 'Design for a "Nubian" evening dress', from *Art, goût, beauté*, May 1924

MAN RAY *Rrose Sélavy* (alias Marcel Duchamp), *c.*1924

This is seen dramatically in the photographs of the surrealist Man
Ray. His portraits of the 1920s vividly combine modernist experimenta-
tion with black signifiers. In particular, his photographs of avant-garde
celebrities such as Duchamp, Nancy Cunard and Kiki de Montparnasse
show how his particular brand of artistry and fashion photography
created the celluloid negrophile.

Reporting on Man Ray's contribution to the first exhibition at the
Galerie surréaliste, held in March 1926, London's *Vogue* noted a 'definite
affinity between many of Man Ray's paintings and the wood carvings
from Oceania', and concluded that, 'No one thinks any longer of disputing
the influence of African and Oceanic work on contemporaneous paint-
ing.'[1] By the time Man Ray arrived in Paris in 1921, interest in African art
was already well established; and his decision to show works from Africa
and Oceania at the surrealist exhibition alongside his experimental
applied art and photography was not novel. As early as 1914 Alfred
Stieglitz had shown African sculptures alongside modern art at the 291
Gallery in New York, which Man Ray had visited. What was new about

Man Ray's contribution to the surrealist exhibition was the way in which *l'art nègre* influenced his images and provided subliminal codings in his work that perfectly suited the transgressive messages of the surrealists.

Man Ray's art was already in tune with surrealist thinking long before his arrival in Paris. He had been friendly with Marcel Duchamp and other avant-garde artists even before leaving New York. He therefore had little difficulty fitting into the vanguard scene in Paris and was quickly introduced to Duchamp's Dada circle. He made friends with Tristan Tzara, Constantin Brancusi and Amedeo Modigliani, as well as with the designer Jean Cocteau, who gave him the appropriate *entrée* into fashion circles. Man Ray later claimed:

> I made lots of friends ... among them Picasso and Braque, who always worked a great deal and who were very successful. My new role as 'photographer' allowed me to go everywhere and become well known. I say 'photographer' because it removes me from the fierce competition that exists among painters. I have something unique, as Jean Cocteau says, 'I have delivered painting'.[2]

MAN RAY *Rrose Sélavy* (alias Marcel Duchamp), 1920

Among the first works that Man Ray produced in collaboration with Duchamp were photographs of the French artist dressed as his fantasy female other/self Rrose Sélavy; pictures that show that Man Ray was conscious of and ready to capitalize on France's fascination with modern America and its flirtation with African-American culture.

The name Rrose Sélavy, separated and pronounced as individual syllables, translates as '*Eros, c'est la vie*' [Eros, that's life]. Jeffrey S. Weiss, in his study of music halls in Paris, also notes that *rosserie* is the French term for a humorous pun used in comic acts. By naming himself Rrose, Duchamp was alluding that his 'life is a pun'.[3] The visual tension in these photographs relies on the viewer's understanding of this play on words and a knowledge of the 'other'. As with their title, the photographs' imagery confirms the gendered and cultural ambiguities that would preoccupy Man Ray, Duchamp and other surrealists over the next decade.

Man Ray's images of Rrose Sélavy contrast sharply with one another: in one, Rrose is lush, sensuous and exotic; in the other, she is arid and unkempt (a look Duchamp would later use to promote his own brand of perfume Belle Haleine Eau de Voilette). Both photographs can be read as being analogous with the collective European psyche. One is weather-beaten and breeds only dust, while the other presents the possibility of renewal by co-opting the exoticism of other cultures within modernity.

The ease with which Rrose changes from the jaded to the seductive exploits the oppositional relationships of black and white culture. The photographs also connect Rrose as sultry negrophile with glamorous products of the American cinema and mass commercial advertising. This is best seen in Duchamp and Man Ray's creation of the packaging for Belle Haleine Eau de Voilette, which features the earlier, fetish-ridden image of Rrose on its bottle. The citation of 'New York Paris', normally used to indicate the location of perfume or fashion houses, in this instance is more telling of the artistic and cultural links which existed within the Dada circle at this time. Duchamp's choice of perfume as a sales product was consistent with the influence that *flacons de parfum* made from semi-precious stones such as emeralds, rubies and amethysts had as fashion accessories in the 1920s. Latent romance and exoticism are reflected in the perfumes' names, such as Siamoise, Femme de Paris, Désire du cœur, Mon âme, YBRY le Bijou des parfums, Cœur enchainé and Fétiche.

In the Rrose Sélavy photographs, Duchamp's outfits show how fashion used exotic forms to suggest regression and rejuvenation. His/her feathered hat and necklace with a snake clasped at the throat, for instance, visually echo what Apollinaire had earlier seen as a fashion trend for fetishes, or as he called them '*gris gris*'. In 1918, he wrote:

by their roughly hewn forms. The photograph helps to define him as a connoisseur of black culture, and as being what Sally Price has described as 'well bred, well schooled, and well dressed, discreet in behaviour, self-confident and measured in judgement', the antithesis of the 'prototypical savage'.[8] Both connoisseur and savage had formed a relationship because of the market in *l'art nègre*.

As a new phenomenon in Paris, African art allowed newcomers like Apollinaire to stamp their authority on its scholarship with relative ease compared with other disciplines in the arts. Even without visiting Africa, and with limited knowledge of ethnography, enthusiasts could set themselves up as arbiters of good taste in the purchasing of African art. Whether Apollinaire would have classified himself as a 'connoisseur' is difficult to discern, but the one person he did acknowledge as such in his 1912 article is his friend and colleague Paul Guillaume. Certainly, Guillaume groomed himself as a connoisseur of both modern art and African art, and capitalized on his association with Apollinaire, who was considered an intellectual and learned about *l'art nègre*. Guillaume gained vanguard credibility as a *l'art nègre* dealer and as editor of *Les Arts à Paris* because of his close association with Apollinaire and the contributions the poet made to that journal.

Like Apollinaire, Guillaume was also photographed in a studio, this time his own. In the background, the one prop that indicates his black interests is the poster for his 1919 'Fête nègre' held at the Théâtre des

Paul Guillaume in his studio, *c*.1930

Champs-Elysées, which marked a highpoint in his career as a champion of African art. At this bohemian *soirée* on an African theme, Guillaume successfully promoted *l'art nègre* through a performance of the early work of another negrophile, the writer Blaise Cendrars, whose later ballet *The Creation of the World* (1923) would fuse European and African theatre forms to showcase avant-garde primitivistic thinking.[9]

The photographs of Apollinaire and Guillaume, pictured in the comfort of the studio, contrast with that of Michel Leiris taken on the Mission Dakar-Djibouti in 1931. This image suggests other readings for the negrophile persona, as well as bearing witness to the trend towards fieldwork in Africa and what the Polish-born British anthropologist Bronislaw Malinowski termed 'intensive participant observation', which became a popular practice among ethnographers and anthropologists in the late 1920s.

Leiris, like Duchamp and Apollinaire, attended Roussel's 1911 performance of *Impressions of Africa*. He was only twelve at the time, but was allowed to attend because Roussel was a close friend of his family. According to Leiris, it was an unforgettable performance that conjured up fantasies of far-off lands and provoked a desire for his own African adventure. He was to make such a journey twenty years later when he was appointed the secretary-archivist on the Mission Dakar-Djibouti. In this capacity, he kept notes on the mission's findings and achievements. But on a more personal level, Leiris kept his own journal of the event, later published as *L'Afrique fantôme*.[10] In this document he described the mission as 'too inhuman to be satisfying', and recorded that it triggered 'an increased erotic obsession, an emotional void of growing proportions', so that despite his distaste for civilized people and the life of metropolitan cities, by the end of his journey he yearned to be home.

Leiris's snapshot reveals some of this discomfort and alienation from the purpose of the mission. For him, the trip represented not merely a trek across Africa but also a journey inwards, an opportunity to explore the self in difficult terrain. His apparent disconnectedness and unease reflect his failure to come to terms with himself and his relationship to Africa. Part of the problem was that his perceptions of the continent were couched in fantasies nurtured by theatrical performances that combined African forms with avant-garde creativity, which had left him with a distorted impression of Africa and its culture.

Whereas Duchamp, Apollinaire and Leiris all projected ideas of primitivism based on fantasy, Man Ray's photography demonstrated the 'primitivized' model in more explicit and didactic codes, allowing it to

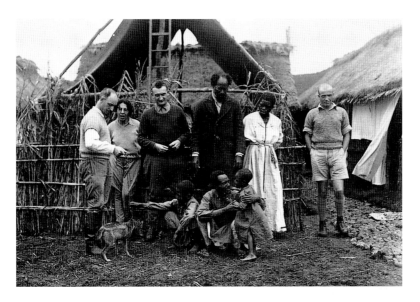
Michel Leiris (on the far right), photographed during the Mission Dakar-Djibouti, 1931

cross over more easily into the popular commercial market that the American photographer courted. He could not go far wrong by befriending Jean Cocteau and Paul Poiret, two key figures who introduced him to the worlds of both *haute couture* and the arts vanguard in Paris. These initial introductions would lead in 1922 to a series of commissions as a fashion photographer. It was through this same circle that Man Ray was to meet Nancy Cunard.

Cunard epitomized the negrophile of the 1920s, and she was in the first wave of élites who inherited the avant-garde enthusiasm for negro forms. Her friendship between 1923 and 1925 with writers and artists such as Tristan Tzara, Brancusi, Man Ray and Louis Aragon assured her familiarity with authentic African artefacts. It also meant that her introduction to Africa and its ethnography took a surrealist slant that was anti-colonial and transgressive. By 1926 she was so enamoured of *l'art nègre* that she wrote to her colleague Janet Flanner to say that she was leaving for Southampton, the English shipping port, 'to look for African and Oceanic things – because that is the most recent and now very large interest in my life, ivory, gods, masks, fetishes'.[11]

As an attractive and wealthy shipping heiress, Nancy Cunard had a lifestyle and fashion sensibility that ensured her the attention of the world's press, and certainly her affection for 'things African' was considered *de rigueur*, as a feature item in *Vogue* entitled 'Ivory shackles' suggests: 'One

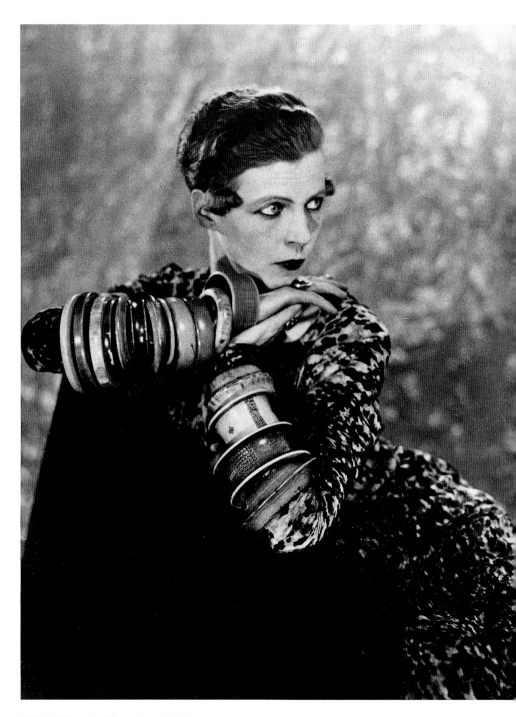

MAN RAY *Portrait of Nancy Cunard*, 1926

thing Nancy did while in London was create a new fashion in ivory bracelets, each of them extremely thick and two or three inches wide.'[12]

Man Ray's photographs of Nancy in 1926 capture her pseudo-exotic personality in poses that beg comparison with his earlier images of Rrose Sélavy. Pictured here sporting bangles up to her elbows, mock-leopard garb and eyes ringed with kohl, Cunard projects not 'otherness' but difference. Her stylish references separated her from conventions of refinement, yet curiously her refinement is reinforced by her accessories: they were intended to enhance and complement, and during this period were read like a shorthand for the 'exotic'. Nevertheless, Cunard's predilection for African forms went beyond the mere sporting of fashion accessories. Despite the censures of her family, she dared to have an affair with the black musician Henry Crowder. It led to her eventual disinheritance and excommunication from the wealthy Cunard family. In the next decade, she was to devote her time to promoting black culture through her role as editor of the anthology *Negro* (*see chapter 6*).

In Man Ray's photograph, Cunard evokes the 'self' and the 'other' within the same frame, projecting an aura which, though cool on the surface, smoulders with internal contradictions. Aside from the sultry stare, this image is devoid of expression, the reading of her character being left to external signifiers: the animal skin which decks the body, and the exotic jewelry honed from animal tusks, metals and woods. These items represent nature, selected because they eschew the urbanized and industrialized lifestyle. Nancy, privileged daughter of a rich shipping magnate, rejects her modernity in favour of this primitivized ensemble. Curiously, nothing about Nancy reads as being explicitly 'primitive', rather the connections are made within the minds of her audience. Significantly, this costume has more to do with animal life than black culture, yet step by step her garb assumes its own visual authority and sucks the voyeur into a swamp of regression to confront archetypal notions of the self.

> Animal
> Animal skin
> Savage
> Human savage
> Savage animal
> Black man
> Black savage animal

Denuding the signifiers here highlights the 'dressing-up' ritual layered onto the image. It is an elaborate illusory performance, and within

the flick of a camera's shutter the taboo statement of regression is made permanent. Yet, in the 1920s, such regression was seen positively by the Parisian avant-garde. It was an inversion that reflected the changing status of blacks in relation to whites, one that suggested they could replenish and revitalize European culture. There was also a distinct regard for black cultural authenticity. In a warped, naïve way, it was felt that the closer an object was to its African origin, the more potent its powers. Hence, even within white liberal thinking, racist myths were perpetuated.

Although it may have suited white Parisians to believe that the blacks with whom they associated were authentic Africans, this was usually far from the case. These blacks, eager to enter white society, accentuated the more entertaining aspects of their culture by exploiting their abilities to sing and dance and to appear comical; at the same time, they also diluted their 'otherness' in order to gain acceptance. The blacks with whom Paris flirted twisted themselves 'outside in' to meet the needs of their white audiences.

Two images of Josephine Baker illustrate this point vividly, the first (*opposite*) taken within days of her arrival in Paris in 1925 while she was preparing for a performance of *La Revue nègre*, the second (*see page 96*) taken less than a year later on the occasion of an erroneous press announcement of her engagement to her manager 'Count' Pepito Abatino.

Seen in the first photograph in what was to become a typical pose, Josephine plays the 'homegirl' country bumpkin. Twisting her body into a pose that looks more animal than human, she crosses her eyes in stupefied mock innocence. As her character from *La Revue nègre*, Fatou, the dancing native who steps out of the dream of a European explorer, she plays into the fantasy that whites create for her. That Josephine could consciously switch into this persona to suit her audience is revealed in her memoirs, as recorded by Stephen Papich.[13] According to Papich, Baker was happy to sing 'Bake that Chicken Pie', despite its racial slurs; to accept a gift of a monkey and later a leopard as her pet companions; and to present herself as Tahitian, if that was what her public desired.

Equally, Josephine could present herself as 'white' when necessary. The second image shows an elegant Baker on the arm of the 'Count'. The camera unflatteringly captures her looking pasty-faced and grinning. The harshness of the flash reveals the extent to which she has masked her blackness in order to appear a fitting 'countess'. Ironically, her fiancé holds not Josephine but the doll of the same name, now bare-breasted

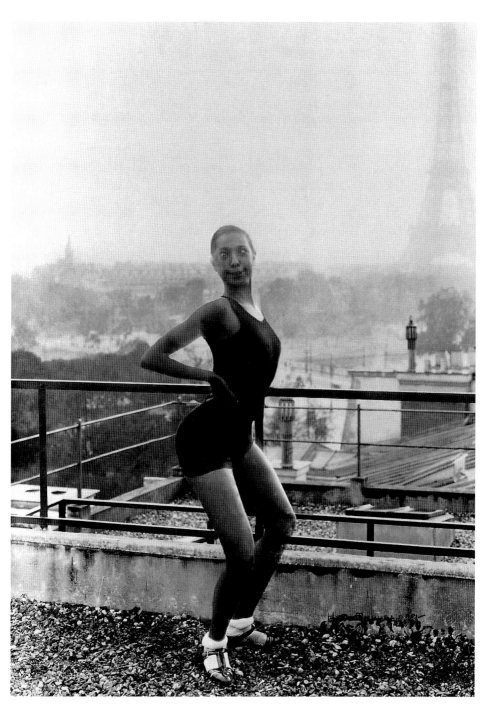

Josephine Baker on the roof of the Théâtre des Champs-Élysées, 1925

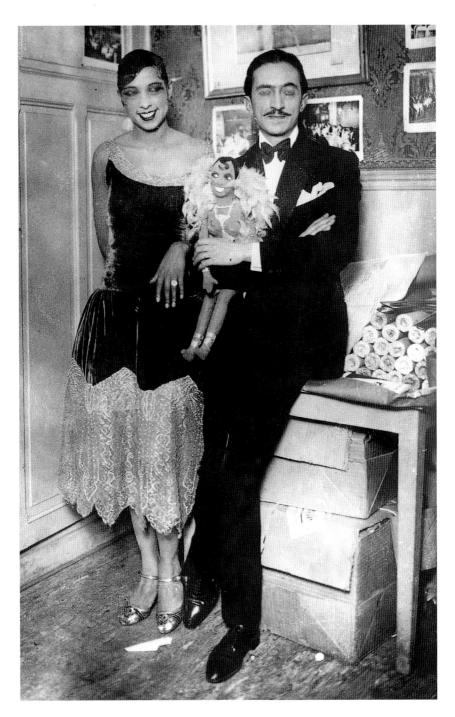

Josephine Baker with 'Count' Pepito Abatino, 1926

but nevertheless wearing the same inane grin. Allusions to puppetry are all too obvious; what are more difficult to discern in this photograph are the motives and scars entailed in such cultural and racial denudation.

Many blacks in Paris bleached their skin, straightened and conked their hair, and tried to dress and speak like whites, in order to assimilate better. Their ability to imitate and deny themselves for the sake of assimilation was an important survival technique, inherited from the experience of slavery. On most plantations during slavery, only the creole or mulatto slaves could qualify as house slaves rather than field slaves. In code, manner and dress, they were expected to emulate their masters and mistresses. This mimicry ensured that the distinctive threat of 'otherness' was less acute for slave-owners. Thus, for a slave to progress from labouring in the fields to an easier domestic or clerical position, he needed to be conversant in the art of mimicry. This self-distortion was one that went beyond the confines of the plantation system. It was a means of advancement that applied even as the plantation economy declined, creating an underclass of blacks anxious to advance in more urban industrial settings.

That most whites were oblivious to this mimicry is understandable, and a credit to the performance of the blacks with whom they interacted. The efficiency of the relationship between the negrophile and the New Negro was based on the fact that he was accessible in a way that his African counterpart could never be. The New Negro was a walking contradiction, combining the potency and exoticism of Africa with an awareness of what it took to be accepted by whites. He had, as Frantz Fanon has aptly put it, 'black skin, white mask'. [14]

The negrophiles, of course, approached this syndrome from the other end of the colour spectrum, and they, too, compromised their racial purity for the sake of contact with blacks. Parisian women even used Bakerfix, the hair product named after Josephine Baker, to give their hair the same short, shiny lacquered look. However, the difference between the black and white conditions was that black people's mimicry of whites resulted from economic necessity, while white minstrelsy resulted, at best, from spiritual deprivation and, at worst, from whim.

All these distinctions and contradictions appear to be captured in *Noire et blanche* (I), a work that Man Ray created in 1926 along with a number of other related images, three of which are reproduced overleaf. The model featured in all of these photographs is Kiki de Montparnasse, singer and sometime lover of Man Ray. Famed for her easy nudity, outrageous behaviour and the artistic circles she attracted, Kiki was known as the 'Queen of Montparnasse'. Her haunts were the jazz clubs of the day –

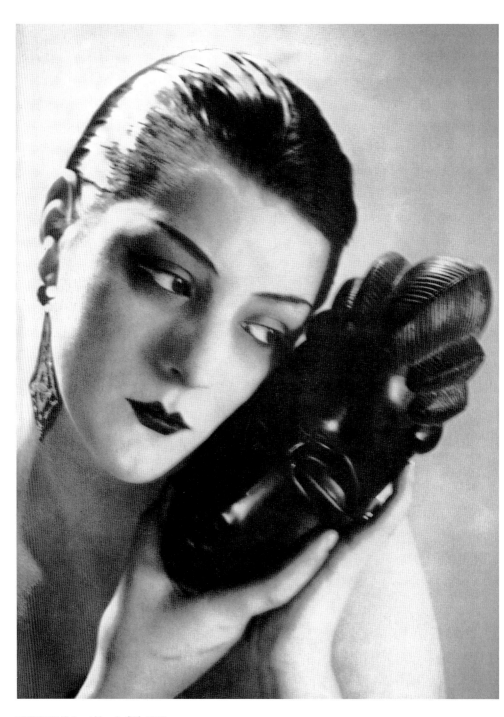

MAN RAY *Noire et blanche* (IV), 1926

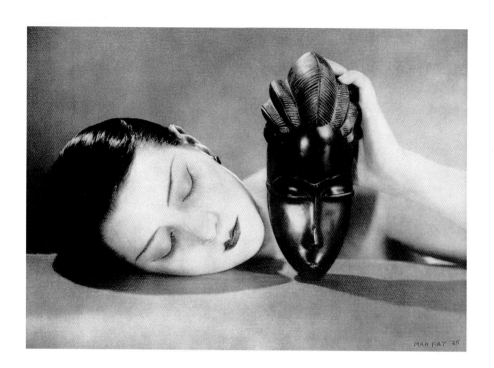

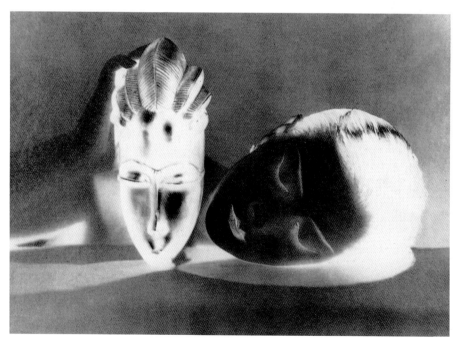

MAN RAY *Noire et blanche* (II), 1926

MAN RAY *Noire et blanche* (III), 1926

Le Jockey, Le Jungle, La Luna and La Coupole – and the daytime cafés Le Dôme and La Closerie des Lilas. Clearly, the significance of *Noire et blanche* (I), which features Kiki's head lying beside a primitivized black mask of a similar shape and in a similar pose, would not be lost on contemporary viewers, who would make the link between the ambivalence of her own dubious character and this 'savage' art form.

The contrasts within the photograph are more numerous than its title suggests, and are not only chromatic, but racial, material and spiritual. Yet, in every respect these contrasts are complementary, creating a harmonious bond. The two heads lying in repose suggest sameness and yet difference, a paradox reinforced by the eerie lighting that creates oppositional plays of light and shadow. Man Ray has consciously constructed a composition where the boundaries of the self and the outer self are explored, teasing out a surreal equation in which black and white are one.

Man Ray works with similar juxtapositions in the other photographs from the series. In *Noire et blanche* (II), Kiki's hand gently secures the upright African head next to her own, which continues to lie in repose. The overall feeling evoked is one of dislocation. This objectification of the images and the removal of contexts allow the pair to relate to each other on equal terms, to trade differences and to enhance similarities. Man Ray's further exploration of this image using 'rayograph' techniques continues his theme of integration through inversion. In the second version of this photograph, *Noire et blanche* (III), the image is reversed as a result of 'solarization', and so too are the tonal values. This complete reversal allows the viewer to see what he or she might otherwise have only imagined before. The mask glows in its whiteness, while Kiki's head is 'negrophied'. The ethereal qualities of the heads are enhanced by the shadows which float like haloes around them.

In another image from the series, *Noire et blanche* (IV), Man Ray alters the positions of the heads and, as a result, the balance of power in how they relate. Kiki is pictured with her head slightly cocked, holding the mask beside her cheek. The fact that her eyes are open, while the sculpture's remain closed, makes her the active partner in the relationship. By fixing the black head with her desiring stare, she seems to possess her partner.

This particular composition summons a level of eroticism, not so keenly registered in the other works, that is similar to that found in Man Ray's pictures of both Rrose Sélavy and Nancy Cunard. In each of the *Noire et blanche* pictures, there is the same expression of longing for 'otherness', the same identification by association with the black form. Yet, placed in relation to its partners, this last image of Kiki and the mask tells another narrative: that the black form, rather than being equal,

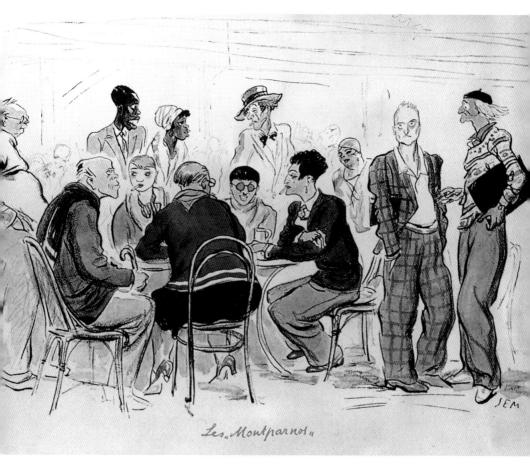

SEM *Les Montparnos*, c.1925, showing Kiki de Montparnasse (seated at table, second from left)

remains the inanimate pawn within this white psycho-drama. As a racial curative, the black can imbue the white with spiritual well-being, but the sense of longing always rests within the white domain, which retains the power to freeze the other with the look of desire. Man Ray's liberalism is consistent with this privilege. Seen this way, the black head loses its earlier sense of equality and becomes a mere prop, its potency receding. With the dialogue between black and white interrupted, the voyeur is implicated and is conscious of intruding on an act of misogyny. The traditional power relationship between artist and model is re-established, whereby props, like people, can be exploited or discarded at will.

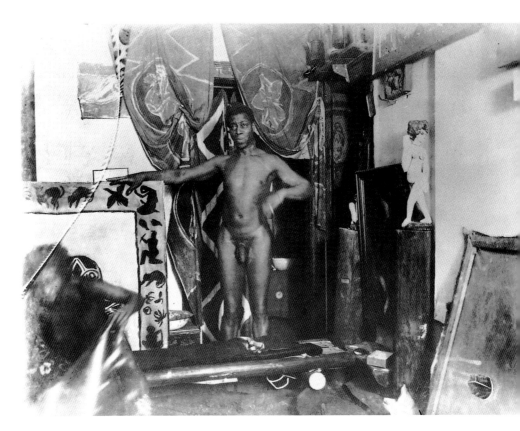

ERNST LUDWIG KIRCHNER Sam and Milli from the Circus Schumann in the artist's studio, 1910

Nowhere is this more explicit than in the image of Sam and Milli, a rare reproduction of the black model 'in situ' within a Western context. This photograph, taken by the German painter Ernst Ludwig Kirchner in his Dresden studio, suggests the psychological alienation that blacks must have experienced when favoured as models by the Western artist. Posed in a corner of the studio, not nude but denuded, Sam is clearly distressed. His limp gaze and limp masculinity reinforce his sense of being trapped and dehumanized. Meanwhile, the blurred image of Sam's partner Milli (bottom-left corner), studied closely, suggests that she is not posing but, rather, moving quickly to cover herself and to avoid this invasion of privacy. Her action suggests that, given a choice, few would have allowed themselves to be modelled in this way.

Techniques involving the juxtapositioning, decontextualizing and isolating of both unfamiliar and overly familiar objects were first intro-

duced by photographers such as Man Ray and Brassaï, but later they became a sort of 'house style' of a number of journals including *La Révolution surréaliste, Documents* and *Minotaure*. By the late 1920s, it is even possible to see the same approach being employed in more mainstream publications such as *Cahiers d'art* and the entertainment journal *Jazz*. The image below of the black singing troupe the Black Birds was typical of this 'house style' as employed in *Jazz*. There is no accompanying information alongside the image to suggest that the group was a successful musical hit in Paris in 1929, nor is there any indication of their New York origins. Instead, the viewer is offered only five pairs of unclad black female legs with costumes rolled up to their hips and the caption 'Les Black birds'. This creative dissection and defacement allows the viewer to read the figures erotically and anonymously; but the image's creativity is subsumed by more serious questions regarding contemporary perceptions of females and blacks.

Beyond such artifice, what was then the context of blacks? Their world on the fringes of white society involved a type of schizophrenia which made even their own perceptions of themselves as blacks difficult. In this sense, their 'masking' was not always conscious, but was rather a neurotic device to cope with difference. The black man's ability to act white within a white world was a very real necessity. In contrast to the negrophile's desire to switch roles, black 'masking' was based on economic and social determinants.

ANONYMOUS 'Les Black birds', from *Jazz*, 1929

ANTOINE 'A wedding couple', from *Jazz*, 1929

Photographs of newly-weds taken by an African commercial pho-
tographer working in the shanty town of Léopoldville (now Kinshasa) in
Zaire serve to illustrate this point. Undeniably, the scenarios within
which these black people are depicted are more real and at times more
squalid than those of their negrophile counterparts. Yet, these photo-
graphs were celebrated by the dissident surrealists for the glimpses they
provided into the lives of blacks in Léopoldville, where so many African
peoples intermingled. Reproduced in *Jazz*, the images ran with a text
which described both the impoverished living conditions of the subjects
and the work of the photographer (known only as 'Antoine, *photographe
nègre*'), whose studio provided the surrealists with an alternative fantasy
about the engaging simplicity of life in urban Africa.[15]

Whether the photographs were taken for the newly-weds or for
others, the desire from this type of studio photography appears to be
the same: to be seen as respectable and prosperous in Western terms.
Pictures were taken to gain approval; they are about attempting to fit
into a mainstream. Yet, despite the props, such images fall short of
Western-style glamour. These stiffly posed blacks are frank, almost
sullen, in spite of their special occasion. The 'gentleman' depicted here is
awkward in a suit too short in the arms and leg, more than likely hired
for his wedding. He is ill-fitted for the role of New Negro.

The issue here is not so much to demonstrate the negro's discomfort in
the face of 'technology', but rather to show that there is little credibility to
the notions of blackness signified in 'negrophile' portraiture. Where are the
bangles and beads, or fur and feathers, and where are the multicoloured
and multi-patterned shorts, skirts and ties? These 'real' blacks deny the
stereotype that whites held about them and suggest other references for
understanding personalities like Josephine Baker. That stereotype had
more to do with the world of nightclubs, revues, parties and the film indus-
try that brought the illusion to life. That stereotype had more to do with
'jazz' as a state of being, a precarious holding ground between two cul-
tures, neither black nor white, but something fantastic and modern; a place
of spontaneity and improvisation, of energetic lively music; a place of
violent bodily motions, erotic gestures and sexual freedoms.

In the case of Paris in the 1920s, we are faced with a type of dou-
bling act: whites act out what they *think* is black, based on stereotypes.
The difference between the negro's and the negrophile's acting is that
one is about material survival, while the other is about the survival of
art, poetry and fantasy. Jazz facilitated this transformation; celluloid
gave it permanence. The images remain long after the party is over, an
eerie reminder of possibilities.

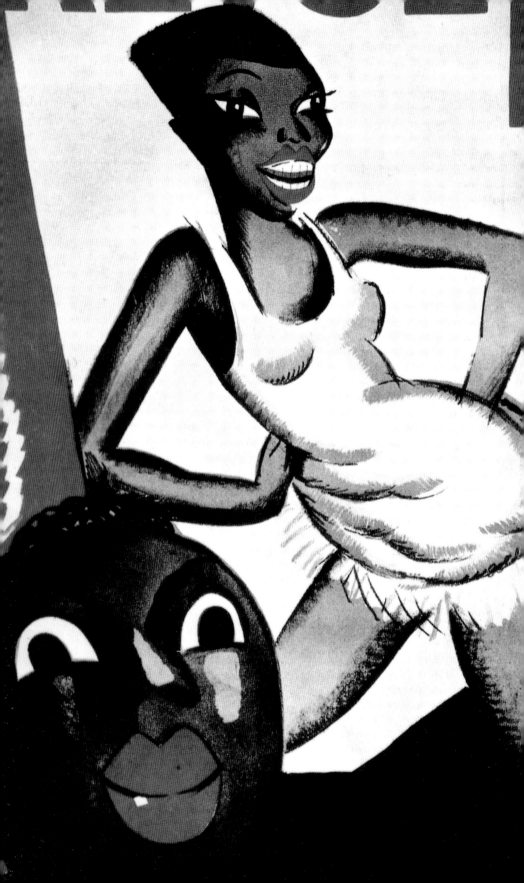

Jazz music promoted the spread of negrophilia in the 1920s. It was fast, raw, noisy, alien and modern. Played in nightclubs, it attracted a young, urban, bohemian audience that identified the music's syncopated rhythms with its own feelings of anxiety and anarchy. This chapter shows how the African-American presence through jazz music and dance played its part in the development of both a modern art form and *l'ordre primitif*, as evident in Blaise Cendrars's ballet *The Creation of the World* in 1923. It also suggests that Josephine Baker's performance in *La Revue nègre* reinforced stereotypes of blacks at a time when Europe's blurred and limited image of them as Africans was changing to accommodate an increased awareness of urban African-American culture.

 Whereas the initial interest in negro forms was fuelled by the arrival of African carvings in Paris, the second wave was much more dynamic – a craze triggered by contact with and appreciation of living black culture itself. The First World War was the crucial event, for it resulted in Europeans gaining face-to-face encounters with blacks. Although of African descent, these blacks were not Africans, however; rather, they were African-Americans offering a black experience different from the connoisseur's cool appraisal of anonymous, undated carvings (a difference alluded to in the 1929 cartoon by the popular New York-based Mexican caricaturist Miguel Covarrubias reproduced on page 186). They provided exposure to a living culture characterized by schism and rupture. Theirs was a culture pieced together from the fragments of plantation slavery; the limitations of an urbanized ghetto existence; the enforced acceptance of white American values; and the bitter-sweet memories of an African heritage.

Viewed from the distance of Europe's avant-garde circles, the genuine African artefact and black culture merged; admiration for blacks was bound up with general ignorance about racial distinctions, geography and a common desire for vitality and potency. Increased contact with 'real' African-Americans meant an intrusion on these dreams, as the imagined 'beatings of the jungle tam-tam' were replaced by '*le hot jazz*'.

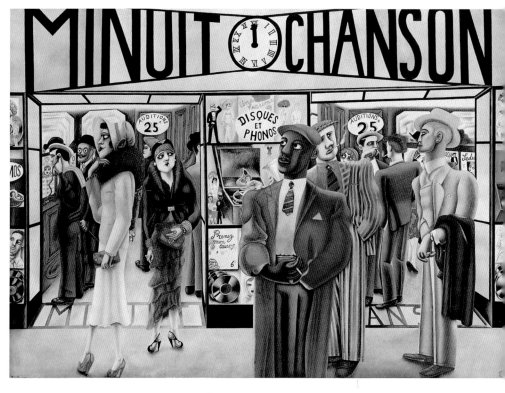

EDWARD BURRA *La Minuit Chanson, Montmartre,* 1931

Jazz came fresh to the European ear because its construction was different from white music. Jazz was polyrhythmic and called for improvisation. It emphasized rhythm above all other elements, allowing in equal measures strong and weak beats. This led to the quickening of pace described as 'swing'. At the end of the nineteenth century, swing was as much a novelty to African-Americans as it was to white listeners. Joel A. Rogers, writing in *The New Negro,* saw it as neither African-American nor white American but a curious blend of rhythms that he considered 'common property' and 'American': 'Jazz has absorbed the national spirit, that tremendous spirit of go, the nervousness, lack of conventionality and boisterous good nature characteristic of the American, white or black, as compared with the rigid formal nature of the Englishman or German.'[1]

Black music had always had rhythm, but swing was a new sound that evolved out of the accommodation of certain European forms into African music. The music that Africans carried with them into slavery was distinctive by its contrapuntal and polyrhythmic nature. It was

tailored to meet the limitations of plantation slavery, often devoid of instrumentation and relying heavily on a cappella vocal support. Syncopation and the swing that characterized jazz was an adaptation of the African form, and an attempt to accommodate the monorhythmic nature of European music. Modern classical composers such as Antonin Dvorák, Claude Debussy and Igor Stravinsky in turn soon adopted syncopation in their work. Their attempts led to a further dilution of the original African sound, and produced a new, almost self-referential form. For these composers, the multi-layering of sounds in jazz met their need to reflect the complexity of modernity and its own unique rhythm, integral to the construction of modern music.

Carried through to other art forms, jazz became an important aspect of modern thinking and art practice, especially for simultanist painters. Jazz represented the pulse beat of modernity, in particular its speed and urban sense of everything happening at the same time. Jazz thus mirrored modern life's simultaneity, which obliterated a linear sense of time and space. Like jazz, simultanist art rebelled against the hierarchical, stressing a polyvisual network of images. And, while syncopation in jazz related to the strengthening of the downbeat, in simultanist paintings all elements of a composition were considered equal – even the most mundane aspects of a composition were given visibility. This democratization of the painted surface involved positive and negative space, foreground and background.

Jazz, African-Americans and the 'new world' of the Americas presented artistic options that were innovative and fashionable for both artists and musical composers. Interest in blacks rested on two opposing perceptions. Firstly, Europeans viewed black people as 'primordial', with all the exotic notions that primitive innocence suggested. Alternatively, they saw blacks as being modern 'new negroes', with a pace that matched an urban lifestyle. The two views were not contradictory, particularly for the avant-garde, which admired black people's 'primitive' condition and believed that it provided a useful model for a postwar modern man. This dichotomy is seen in the 1923 ballet *The Creation of the World*, a theatrical performance in which modern and primitivized forms blended easily together.[2]

The Creation of the World was a production by the Ballets Suédois, which, under the direction of manager Rolf de Maré and choreographer Jean Borlin, provided an alternative to the modern dance forms of Sergei Dhiaghilev's Ballets Russes. *The Creation of the World* epitomized what critic Maurice Raynal considered 'a new art and a new aesthetic sensibility'. Its concern for a fusion of art forms, seemed to mirror artistic

ideas held by Robert and Sonia Delaunay, Fernand Léger and other simultanist painters. *The Creation of the World* featured a *mélange* of the arts; it also celebrated avant-garde thinking, and for this reason the production attracted a number of artists renowned for their innovative expertise. Blaise Cendrars's *Anthologie nègre*,[3] translations of African mythology, provided the poetic narrative on which the ballet was based; choreography was by Jean Borlin; the score, shot through with contemporary jazz idioms, was by Darius Milhaud; and the set and costume designs were by Léger.

Léger's prewar paintings had depicted men climbing or descending stairs, exploring man's relationship to modernity and the notion of regression. On his return from the front, his paintings shifted to dull mechanized tubelike men in factories and modern industrial settings, and raised issues about the uncertainties of civilization, evolution and the relationship of man to his environment. Léger's designs for *The Creation of the World* were a resolution of these opposing themes, and posited notions of rebirth and regeneration crucial to his ideas about postwar man. Although Léger's reference to African forms was a stylistic departure, his collaborations with Cendrars, Milhaud and Borlin, and his continued interest in the primitive, suggest that at this time African forms became a metaphor for origins and their aspirations for modern society. His designs for *The Creation of the World* represented a positive statement about his vision for postwar France. It posited *l'ordre primitif* based on African models of civilization.

Cendrars, too, hoped that the African myths that were the basis of *The Creation of the World* should become a source of renewal and instruction for postwar France. His experience in the trenches, like those of so many of his contemporaries, left him questioning the barbaric nature of war and the psychic scars it would leave. Cendrars's material for *The Creation of the World*, and for the earlier play *The End of the World* (1919), suggests that the war was a watershed for mankind and the signal for new beginnings. Written immediately after the war, *The End of the World* was a visionary and disturbing work reflecting Cendrars's pessimism about the condition of Western man. Like the biblical Book of Revelations, it foretells God's judgment of the earth.[4] Fittingly, a black man, Menelik, plays a significant role in the play as God's adviser and the prophet who heralds the new world that will be the subject of *The Creation of the World*.

Blaise Cendrars's poetic translations of African stories for *The Creation of the World* reflected a fashionable interest in anthropology among the avant-garde.[5] The level of ethnographic research that

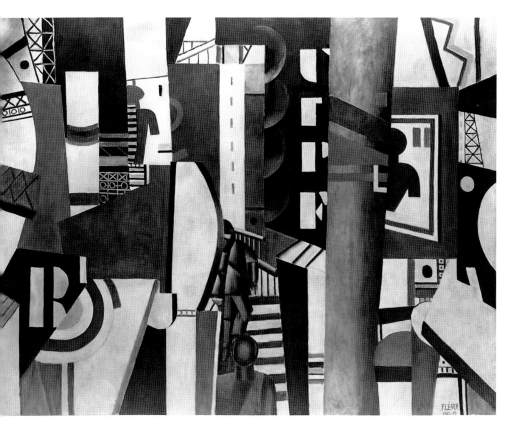

FERNAND LÉGER *The City*, 1919

went into this adaptation of African culture was unprecedented. African folklore, dance and design were all used as source material for the production. The narrative explored the genesis of life from an African perspective. Pantheism being central to the African beliefs, this story of the creation takes place in the presence of totemlike deities who preside over an ever-changing landscape.

Despite this 'grafting' of ideas about Africa onto a European performance, the finished product successfully created a modern genre: a balance between 'classical' and primitivized forms. Milhaud's score accompanying the narrative was majestic and hauntingly sonorous. Drawing on his Harlem jazz experiences, Milhaud created a symphony that combined the swing mood with a classical French style. All this was complemented by Léger's colourful costumes and scenery. Léger wanted an element of surprise in these, achieved through the juxtaposition of

traditional and contemporary forms. His most interesting innovation was the creation of a sense of mobility. He designed his costumes as if they were masks for the body that blended individual performers into the collective whole of the stage set. Léger wanted them to fuse with the set, like moving scenery. A cursory look at his costumes and backdrops shows a relationship with the fragmented simultanist paintings that characterized his work in this period. But, like Cendrars, Léger's major source was African sculpture. He copied and redesigned drawings from African masks reproduced in Carl Einstein's *Negerplastik*[6] and Marius de Zayas's *African Negro Art and its Influence on Modern Art*.[7] It was a clear example of the old inspiring the new. And, although Léger's Africanized forms represented a stylistic tangent, conceptually there was continuity. They fitted easily with his concerns about fecundity and creation. Although the production's music, dance and artistic directors did not actively collaborate, it is clear that all shared Léger's formalist sentiments. Each researched their African ethnographic material carefully and demonstrated a respect for authenticity, not always apparent once black culture became more popular.

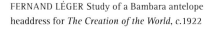

FERNAND LÉGER Study of a Bambara antelope headdress for *The Creation of the World*, c.1922

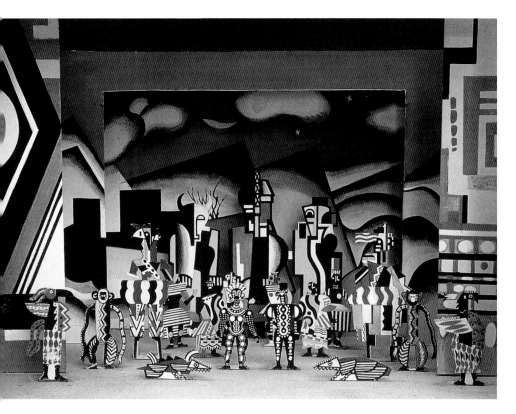

FERNAND LÉGER Stage set of *The Creation of the World*, 1923

Jazz experienced a sudden rise to popularity in Paris in the mid-1920s. '*L'epidémie*', '*le virus noir*', '*la rage*' were all terms used to describe the phenomenon. The music critic André Cœuroy, writing about jazz in 1926,[8] marvelled at the fact that only a year earlier he had gone to pains to investigate the origins of the music for a public largely ignorant of it. These descriptive terms indicated the speed with which jazz was accepted; but they also echoed notions about degeneracy that contributed to jazz's appeal within certain circles. For critics like Cœuroy who favoured jazz, the new music was invigorating and capable of regenerating exhausted European forms; but for the more sceptical of commentators, such as André Levinson, jazz represented 'bad blood' that could lead only to decadence and malaise for European culture. For Levinson, fans of jazz music were 'devil-ridden'.

André Levinson was perhaps the most knowledgeable dance critic of the day, and he took a very pessimistic view of jazz's influence. In

his journal *La Danse d'aujourd'hui*,[9] he described it as yet another flirtation in a string of dance forms, soon to be exhausted. But Levinson was far more pejorative about jazz than other types of modern dance. In his 1927 article 'Danses nègres', he set himself the challenge of analysing jazz with the same amount of academic rigour that had been applied to other musical forms, such as ragtime. Tracing the history of negro musical forms, he implied that jazz dancing contained a pathological trait originating from more primitive societies, and as such it was 'contagious'.

For Levinson the ambivalence of jazz arose from the moral implications of its popularity. He suggested that Europe had subjected itself to a 'black virus' that may prove a corrupting influence. His moral argument mirrored a genuine concern for purity of race, to which jazz posed a threat. The performance of jazz dancing was a highly sexualized event, with innuendos not lost on the viewer or the critic. Certainly, sexual dynamism was the most distinctive aspect of jazz dance for Levinson – but it was not the most worrying. In an analysis of tap-dancing, he equates the difference between jazz and more traditional forms with a difference in human development between two cultures. The noise and brutality of tap-dancing are paired with the vulgarity of the peasant, while the poise, quietude and discipline of ballet are seen as civilized. White preoccupation with jazz dance forms represented a cultural contradiction that was disquieting.

If jazz was the corrupting aspect of African-American and American culture, then Europe's equivalent was the music hall. Perhaps the most controversial of all music-hall presentations was the revue, which combined topical satire with spectacle and political comment. In France, music hall revues first appeared in the 1820s, had a revival in popularity after 1910, and peaked during the war years. A revue could be staged at any time, but it was traditionally popular in late autumn or winter, when it served as an annual review summarizing and highlighting pertinent events of that year. Although it might combine a variety of acts, such as the chorus line, slapstick comedy, acrobats, juggling and magic, its spectacle centred around an informed and entertaining commentary. The fact that it presented current events within an often pornographic and satirical format meant that the revue could be controversial and subject to censorship. Imagine, then, the prospect of an all-black 'jazz revue', the fusion of two radical art forms from two opposing cultures, and the *succès de scandale* such a combination anticipated. *La Revue nègre* at the Théâtre des Champs-Élysées in 1925 was just such an event.

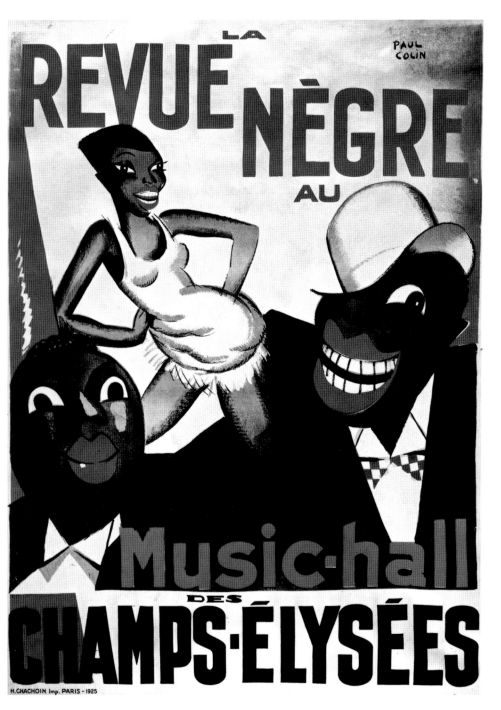

PAUL COLIN Poster for *La Revue nègre*, 1925

The popularity of black variety performances like the 1921 musical *Shuffle Along* in New York suggested that a similar venture might be successful in Paris, a city increasingly intrigued with black culture. It was Fernand Léger who made the initial suggestion to Rolf de Maré, manager of the Ballets Suédois, that an all-black troupe could be the basis for a new production in Paris. From there, the practical side of preparation was taken up by Carol Dudley, wife of a rich American diplomat, who spent time in New York putting together a cast of popular black entertainers. The event was to be staged in October 1925, coming at the end of a year that had already seen a spattering of jazz *soirées*, as well as a new awareness of African culture witnessed in the displays of that year's Exposition internationale des arts décoratifs.

The atmosphere surrounding the *La Revue nègre* shows that its organizers recognized that they were risking both their reputations and their artistic standards for profit. Even the choice of the Théâtre des Champs-Élysées as the venue reinforced this idea of a fall from grace. For a high-class theatre situated in a reputable area, its takeover by Rolf de Maré, for the purposes of housing the new company, as well as other music-hall productions, was seen as a move down market. If the

WALÉRY Josephine Baker as Fatou in *La Revue nègre*, 1925

memoirs of Moulin Rouge producer Jacques Charles are to be trusted, on seeing the motley crew of black performers arriving for rehearsals, André Daven, the director of the Champs-Élysées, and de Maré were horrified by their unruliness and incessant tap-dancing. Daven remarked, 'Only you can fix this up, if you want to use these Africans, I want no part of it.'

La Revue nègre introduced a young Josephine Baker to the Parisian stage, and it was her opening-night performance that ensured the success of the show. The most vivid record of the event is Paul Colin's print portfolio *Le Tumulte noir*. Josephine's image dominates the portfolio, and it is clear from the visual and literary assessment of her performance that her presence evoked deeply rooted notions of the erotic and the taboo. Colin, describing his first contact with the revue performers, offers a written account that parallels his *Le Tumulte noir* images:

> At ten o'clock one morning I watched a colourful raucous group swarming toward the theatre, devouring their latest find, croissants from a bistro on the avenue Montaigne. Harlem was invading the Champs-Élysées Theatre. Leaping onto the stage like children at play, the troupe broke out into a frenzied tap-dance. With bright-coloured neck ties, dotted pants, suspenders, cameras, binoculars and green- and red-laced boots, who needed costumes? What style. The stage-hands stopped open-mouthed in the wings, and from our seats in the hall, Rolf de Maré, the theatre manager, André Daven, the director, and I sat gaping at the stage. The contortions and cries, their sporty perky breasts and buttocks, the brilliant coloured cottons, the Charleston, were all brand new to Europe.[10]

The language is flagrant and vivid, and it frames the black dancers in caricatures rooted in colonial thinking. The negro is portrayed here as childlike and playful, while simultaneously being animal-like and sexual. These identities were consistently promoted and 'normalized' by those who later wrote about Baker. Her personas ranged from merry and mischievous to savage and deviant.

The real Josephine Baker was a young Harlem-based dancer who developed her dancing techniques from mimicking the vaudeville act of 'Bert and Bennie' at the Cotton Club. She was 'street-smart' to the ways of Americans, but ill-prepared for the complex adoration of the French. Her willingness to pose naked for Colin and to dance topless on stage, however, transformed her into a mythical 'black Venus'. On her début, when she was dressed solely in a ring of banana's belted across her hip, her expressive dancing, combined with jazz, roused the

audience. Even as stringent a critic as Levinson could not resist her gyrations. He wrote:

> Certain of Miss Baker's poses, back arched, haunches protruding, arms entwined and uplifted in a phallic symbol, had the compelling potency of the finest examples of Negro sculpture. The plastic sense of a race of sculptors came to life and the frenzy of African Eros swept over the audience. It was no longer a grotesque dancing girl that stood before them, but the black Venus that haunted Baudelaire.[11]

Comparisons with African sculpture were not lost on the viewer. Present in the audience on Baker's début night were the artists Francis Picabia and Kees van Dongen and the writers Blaise Cendrars and Robert Desnos; and in the following months and years other artists and writers, including Pablo Picasso, Tsugouharu Foujita, Henri Laurens, Georges Rouault, Marie Laurencin, Louis Aragon and Alexander Calder, and architects such as Le Corbusier and Adolf Loos, would seek her out as model and muse. For most artists, Baker was a romantic fantasy from a Gauguin or a Henri Rousseau painting come to life. Jean Dunand painted her in an exotic setting of banana and coconut trees dressed in

ALEXANDER CALDER *Josephine Baker I* (*Danse*), 1926

skimpy stylized African garb and holding an African charm. American sculptor Alexander Calder devoted his first completely wire-framed sculpture to a figure of Josephine, the basis of a later mobile that suspended from the ceiling mimicking her '*danse de ventre*'. In an era when artists were grappling with a polarized view of women that embraced both the creative and the subversive, Baker was an icon of female sexual expression. Her image was a powerful one because she appeared to have liberated her female sexuality, and also because her blackness and the fantasy of her accessibility threw into contradiction social and moral mores regarding both sex and race.

Baker's presence dominated the première performance of *La Revue nègre*, which offered a variety of entertainment in keeping with an annual revue. The programme opened with traditional juggling and circus acts, with the black troupe billed to perform after the intermission. The second half of the show, given over completely to the black performers, involved a set change to a backdrop designed by Miguel Covarrubias. The idyllic setting, more evocative of a Pacific island, set the tone for the 'African' dancing that followed. The show was hosted by a master and mistress of ceremonies, the '*compère*' and '*commère*', who for this presentation were uncharacteristically black. It was they who called the performers onto stage, as well as keeping up a banter of social commentary between the acts.

Excerpts from the script indicate that the revue's humour was based upon the 'in' dance craze of the charleston, as well as upon racist jokes that even involved whites laughing at themselves. The humour was not so much political as subversive. As a joke taken from Josephine's 'Topic of the day' script shows, 'I may be a dark horse, but you will never be a black mare.'[12] Along with these interludes were song couplets performed by dancing women.

The most popular form of music-hall dancing in Paris at the time was the chorus line, in which scantily clad women performed a tightly drilled routine involving formations and high kicks. Jazz dancing was diametrically opposed to this type of rigour, and the producers had to give in to its free-flowing structure by allowing for a certain amount of spontaneity within their programming. It was through this concession that Josephine's talents came to the fore. Although she was not billed as the lead dancer, her provocative antics during rehearsals and her popularity on opening night earned her a reputation as *La Revue nègre*'s star performer. 'La Danse sauvage', her routine, took different forms according to her moods and costumes: sometimes comical and idiotic, sometimes sexual involving a male partner, sometimes animal-like and atavistic.

Based on a mishmash of borrowed dance routines and her own high-spirited interpretation of the savage, Baker's dance presented her 'civilized' audience with an experience that it perceived as being raw and authentic.

Reports of the success of *La Revue nègre* come from a variety of sources, but none is truer to the spirit of its performance than Colin's *Le Tumulte noir*. At its best, the portfolio represents a stylish record of an élitist fascination with black culture; at its worst, a product of European phobia that was itself atavistic. The prints featuring Baker were created in the months following her début. The preface, written by the poet (and later Baker's biographer) Marcel Sauvage, assessed the craze of negrophilia, or as Sauvage called it '*négropathie*', and used puns and flagrant language to describe the craze surrounding Josephine herself.[13] For Sauvage, Baker's success represented the final triumph of '*la vomito nègre*' over the whites in Paris: white enslavement to jazz was sweet revenge for slavery.

In preparing his portfolio, Colin exploited these 'base' notions of blackness by using stereotypical images. His work was transgressive but suited to the provocative themes of the revue. His images also suggested

PAUL COLIN 'Légeresque figure', from the *Le Tumulte noir* portfolio, *c.*1925

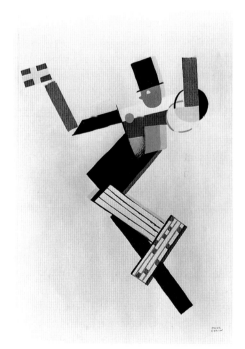

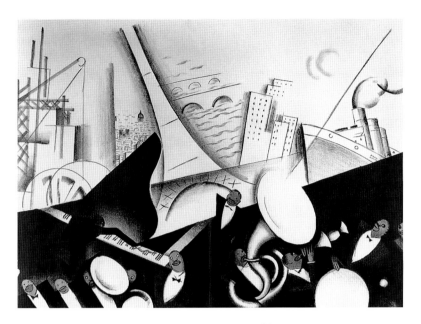

PAUL COLIN 'City musicians', from the *Le Tumulte noir* portfolio, *c.*1925

ambivalence. His easy reference to minstrelsy, golliwogs, dandies and animal-like performers placed his work within a tradition of black imaging already seen in advertising. In general, Colin juxtaposed the various stage personas of Baker with images of the rest of the troupe in different routines and dance settings. His style shifted awkwardly between commercial and fine art, blurring the traditional divide between 'high' and 'low' forms. Certain prints mix references to Fernand Léger's *The Creation of the World* designs with caricatures borrowed from Harlem music-hall posters; others exhibit distinctive advertising-style designs; while some show his effort to employ modern-art styles.

In the work opposite, for example, Colin struggles to render an image of a top-hatted tap-dancer in a style similar to Léger's backdrop for *The Creation of the World*. His use of colour, however, is flat and dull, and the work lacks Léger's confident brushwork. Only in the image above does Colin arrive at a balanced composition that in its Art Deco quality approaches Léger's 'modern life' sensibility. This poster, complete with the Seine, Eiffel Tower, ocean liner and musicians, all eyes and mouths, creates a lively urban scene that refers to the New Negroes' settlement in white cities. But because they are placed on the edge of the city, in the orchestra pit at the bottom of the picture, they seem peripheral and alienated from the cosmopolitan setting above.

Colin's *Le Tumulte noir* portfolio demonstrates the power of the print as a visual medium for reinforcing colonial perspectives. The designs can be added to the stock of cartoons enjoyed over centuries that perpetuated myths about the negro. The success of these caricatures depended upon how regularly they were seen. For the stereotype to be effective it had to be both fixed and fluid; to appear unchanging, but also to remain open to manipulation. Homi Bhabha considers this act of repetition conjoined with fixity to be a deliberate strategy used by those creating a stereotype, which he defines as 'a form of identification that vacillates between what is known and something that must be anxiously repeated'.[14]

For the most part, Colin's characterizations of blacks were formulaic and repeated the usual range of stereotypes: childlike, animal-like, savage. Interestingly, however, comparing his first pictures of Josephine with the later portraits, it is clear that her image develops from a stereotype into a savage persona, and finally to a more considered and humane description. Colin's later handling of Baker's female form is far more studied, the range of characterizations probably developing out of his closer relationship with his subject.

Colin's images of Josephine were iconic. They became seen as symbols of black female sexuality, and consequently Baker's antics were viewed as characteristic of her race. Baker's willingness to adopt certain poses for Colin did little to dispel these racial prejudices. Her preferred stance – body in profile, breasts out, buttocks protruding – simply reinforced age-old notions of black female erotica. In the eighteenth century, Sarah Baartmann, a black South African woman, had been posed in a similar way to validate a pseudo-scientific appraisal of Hottentot women. A study, supported by medical drawings and documentation, claimed that Baartmann's buttocks and genitalia were a sign of deviant sexuality. After this, she was toured through Europe as a scientific spectacle. The success of this touring 'circus' contributed to the popular association in the late nineteenth century of black women with prostitutes. Josephine's modelling furthered these ideas.[15]

Colin's first poster for *La Revue nègre* (*see page 115*) employs an exaggeration of Baker's features: she has a large grinning mouth, accentuated by heightened lip colour (in this case, scarlet red), and wide bulging eyes with small startled pupils. Careful not to offend the sensibilities of a potential audience, Colin titillates the viewer by placing Baker in a white chemise hitched up above her thighs. His image comes directly from Covarrubias's drawing *Jazz Baby*, which promoted the American ballet *Within the Quota*, performed in Paris in 1923, demonstrating how

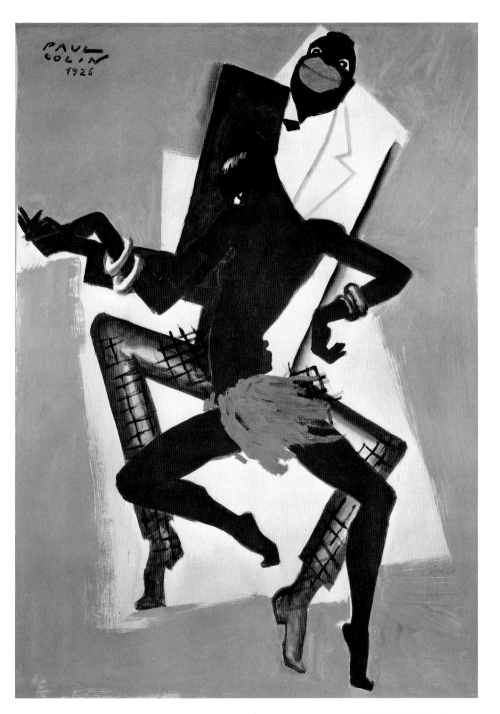

PAUL COLIN *Bal nègre*, 1926

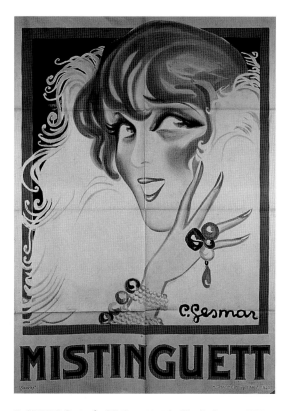

C. GESMAR Poster for Mistinguett at the Moulin Rouge, 1925

African-American stereotypes were carried over to Europe. The reference to sexuality is carefully muted, but is still antithetical to contemporary depictions of white women in music halls. A contemporary poster of the white performer Mistinguett reveals this disparity (*above*).

Mistinguett had reigned supreme in the music halls of Paris prior to Baker's success. Her poster from the same period projects her coy sensuality, indicated by her flirtatious eyes and rosy cheeks, an innocent contrast to the savage images of Josephine. The rivalry between the two performers was soon played up by the press. In October 1926, within a year of Josephine's début, *Vogue* featured a picture (*opposite, top*), not unlike Manet's *Olympia*, of Mistinguett attended by her black servant, with a caption that questioned who was indeed the true empress of the music hall. The question clearly alluded to Mistinguett's rival, who was fondly referred to as the '*Impératrice*' (the 'Empress'), and who was rapidly winning the hearts of the French. Baker's Christian name,

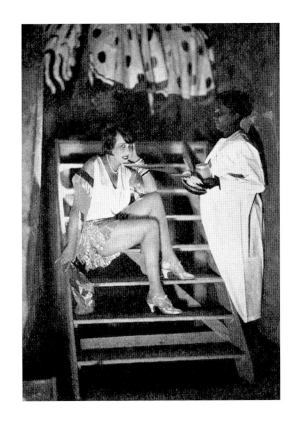

'Mistinguett attended by
her servant', from *Vogue*,
October 1926

ÉDOUARD MANET *Olympia*,
1863

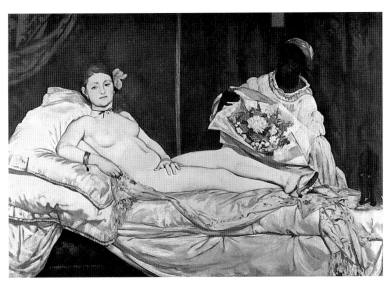

PAUL COLIN 'An elegant Josephine in banana skirt', from the
Le Tumulte noir portfolio, *c*.1925

combined with her creole background, led to her being compared to
Napoleon Bonaparte's first wife Joséphine, whose image also experi-
enced something of a fashionable revival in the 1920s. The combined
identity of the two 'Joséphines' created serious competition for
Mistinguett, previously considered the 'queen' of music hall. The con-
ceptual difference between Baker's and Mistinguett's performances was
also recognized at that time. In contrast to the blonde-haired and blue-
eyed Mistinguett, whose gaminelike performance was sentimental and
glamorous, Josephine represented something far more 'primitive' and
therefore modern.

Ignoring the undeniable crudity of Baker's famed 'banana dance',
Colin chose to aestheticize the performance for his *Le Tumulte noir* port-
folio. The ring of fruit that projected suggestively while Josephine writhed

her hips in the original performance becomes a tutu in Colin's design (*opposite*). Baker is depicted like a nymph. Viewed from the side, with her body elongated and skin tone lightened, this is a vision of Josephine modified to suit Western notions of refinement. Contrast it with the image of her as an awkward and gaudily dressed character, dwarfed, black and ill at ease in the city (*below*). But Colin focused more often on Baker's animal-like persona. In many of his *Le Tumulte noir* images, her sexuality and ferocity are implied by the violence of her movement and

PAUL COLIN 'Josephine in the city', from the *Le Tumulte noir* portfolio, c.1925

the contortions of her body. And in 'Josephine behind bars' (*opposite*), her splayed legs and vampish look, the regular criss-crossed stripes and the startled onlooking musician suggest a caged animal with a voracious appetite. Reviews of Josephine's performances concurred with these visual references. The overwhelmingly popular image noted by critics was that of Josephine as animal, an association that she seemed actively to promote in her performances and real life.[16] Colin played on this association in a disturbing work that combined the modern 'spirit' with its primal ancestor. His depiction of a '*Homo caudatus*' – a tailed man – underscored the living memory that Josephine's performances must have provoked:

> This is no woman, no dancer, it's something as exotic and elusive as music, the embodiment of all the sounds we know ... and now the finale, a wildly indecent dance which takes us back to primeval times ... arms high, belly thrust forward, buttocks quivering, Josephine is stark naked except for a ring of blue and red feathers circling her hips and another around her neck.[17]

PAUL COLIN 'Epidemic: the old lady', from the *Le Tumulte noir* portfolio, *c*.1925

PAUL COLIN 'Josephine behind bars', from the *Le Tumulte noir*
portfolio, *c.*1925

Colin's images also played on European fears about the degenera-
tion of the white race. The success of these images relied upon the
presence of white and black within the same frame. The juxtaposition
challenges the taboo of racial association, while giving Colin an oppor-
tunity to express his simultaneous excitement and disgust at the
prospect. Colin treats the whites as interlopers, the partners of blacks
who, despite their stereotypical features, are very much of their time;
Colin depicts his subjects with a lurid realism that captures both white
and black in the act. And, occasionally, Colin proves that he respects no
one – black or white – by depicting Parisian '*dames*' with as much
disdain as he does the blacks, vulgarizing them by their very presence, as
well as through the ways he represents them (*opposite*). These images are
no longer about controlling, but rather about a society losing control –

PAUL COLIN 'Voyeur and monkey-like dancing girls',
from the *Le Tumulte noir* portfolio, *c.*1925

about letting go. At no point is this more heightened than in the image above. Here, a voyeur, a disturbing figure of ambiguous race, sex and species, starkly defined in black and white, is juxtaposed with a trio of black chorus girls. Like adolescent monkeys, they kick their legs in the air to receive the smoke that is emitted from the erect and suggestively phallic cigarette held by the observer.

These images cannot be assessed in purely aesthetic terms; the racist notions inherent in them must also be acknowledged. In 'Voyeur and monkey-like dancing girls', Colin reveals the code which underpins his work. The conscious metamorphosis from animal to human form is indicative of the pervasive sentiments of the age. *Le Tumulte noir* expressed the latent fears and desires of one culture for another, its visual crudity being matched by an ideological crudity. But artists make visual statements; they signal a 'moment' in time that cannot be altered later. In the case of *Le Tumulte noir*, the work's very value and intrigue as a visual record rests on the irrevocability of its forms.

Colin was not naïve, however; he consciously played with the ambivalences of his era. Within the context of postwar Paris, Josephine's

Surrealists represented the extreme left wing of avant-garde art practice in the late 1920s. Their appreciation of black culture reflected this extremism. Precursors of Dada and surrealism, such as Guillaume Apollinaire and Marcel Duchamp, had been drawn to *l'art nègre* as an exotic accessory; but surrealists such as Georges Bataille and Michel Leiris, who had come to appreciate black culture through their interest in ethnography, wanted to sensationalize its more lurid qualities further. The negrophilia they advocated was far more transgressive than popular sentiment allowed. They went beyond a frivolous aestheticizing towards a 'hard primitivism'[1] involving an interest in sexual deviance, fetishism, magic, ritual practices and cannibalism as a way of critiquing and transgressing the norms of European society. Artists such as the Romanian sculptor Constantin Brancusi and the Swiss sculptor and painter Alberto Giacometti picked up on these trends. Their work did not always overtly use or mimic African art, but blackness was part of the hidden language of signs and ideas that conceptually excited their work.

This chapter examines this 'darker' side of avant-garde practice. It is concerned mainly with deconstructing the 'constructed' images of Bataille and Leiris in the magazine *Documents*.[2] First, however, by examining the sculptures of Brancusi as an early influence on Giacometti's work, it shows how the later use of juxtaposition in *Documents* set blacks at odds with mainstream values. Further, it also explores the network of dissident surrealist ideas that made connections between Giacometti and the Black Birds troupe; between black sexuality, subversion and deviance.

By 1925, when Giacometti decided to settle in Paris, Brancusi had already run the gamut of his experimental works, and had settled into the recognizable minimal style that is distinctive of his later work. But between 1910 and 1920, he had been actively experimenting with African forms. Intrigued with spontaneity, he used a *'taille direct'* method of carving straight out of wood that challenged the classical tradition of modelling. In this way he created works with roughly hewn

An illustration from *Documents*, 1930, no. 8, often attributed to Boiffard, a regular contributor to the journal. In the text accompanying the photograph, however, Leiris states that it was the writer William B. Seabrook who had 'conceived' the image and had it 'executed' in New York.

(*above left*) CONSTANTIN BRANCUSI *The First Step*, 1913 (destroyed except for head)

(*above right*) CONSTANTIN BRANCUSI *The Beginning of the World*, c.1920

surfaces, such as *The First Step* (1913), *Madame L. R.* (1914?–17), *Little French Girl* (1914–18?) and *Adam and Eve* (1916–21), that were suggestive of African sculpture but which also connected with his own peasant, Romanian heritage. It is possible that Brancusi's initial fascination with African forms was triggered by a recognition of the qualities that African and Romanian carving shared.[3]

Brancusi appreciated the conceptual simplicity of African art and its functional relationship within religious and spiritual ritual, but was less impressed with its crude appearance. Gradually, he rejected the rough surfaces and African styling of his works by carefully cutting and painstakingly polishing and refining them so that they bore few scars of a material existence and showed no sign of African inspiration. He wanted his sculptures to be perfect objects, transcendent and pure, with a sense of power communicated from within the form. From around 1919, he created works such as *The Beginning of the World* (c.1920), *White Negress* (1923) and *The Chief* (1924–5), which all still owed much to African art, but communicated otherwise. Like platonic prototypes, they appear other worldly.

The Beginning of the World, with its egglike shape derived from *The Newborn* of 1915, called for a new world order. It suggested a fresh start after the First World War, based on simpler values and a more primitive existence. In this, the work echoed the sentiments behind the Ballets Suédois's *The Creation of the World*[4] of the same period, and, like the

CONSTANTIN BRANCUSI *The Newborn*, 1915

CONSTANTIN BRANCUSI (*above left*) Photograph of *Blonde Negress*, c.1926 (*above right*) *White Negress*, 1923

ballet, it represented an aestheticized blend of two distinct cultures. It achieved sculpturally what Brancusi's close friends Erik Satie, Darius Milhaud and Francis Poulenc had achieved musically: fusing classical forms with the energy of African art.

Brancusi's exacting nature and insistence on a sort of ritual purification by polishing made an anomaly of the roughly hewn negro works that he kept in his collection. The answer, for Brancusi, came through his use of them as opposites. By juxtaposing one form against the other, and by conceptually combining the flawed with the purified, he played off a European aesthetic against an African one. For him, the base was important to the power of his work, therefore he created an 'other' Brancusi, a polarized negative of each piece to stand beneath or behind or even within it, empowering his softened forms with an even greater sense of refinement.

CONSTANTIN BRANCUSI *Portrait of Nancy Cunard*, 1925–7 (back and profile views)

Brancusi's various *White Negress* and *Blonde Negress* pieces are works that gain their strength from such built-in tensions. His choice of titles and materials suggests his playfulness. Photographs of the sculptures show how he set one form against the other, underpinning the negresses' smooth, svelte surfaces with contrasting rough, crude or angular forms beneath.

Unlike the bronze and marble used for the *Blonde Negress* and *White Negress* pieces, Brancusi used hardwood for the 1925–7 *Portrait of Nancy Cunard*, the earliest of his two portraits of the English heiress. Apart from Cunard's chignon, and the negresses' exaggerated lips, all three works are similar, yet they signify differently. The *Negress* works are squat, rotund and rooted, while the *Nancy Cunard* soars heavenward, the swell of Nancy's form thrusting the image upward away from the base, and her birdlike chignon reinforcing the movement.

A photograph by Brancusi of his studio, showing two of his large and roughly hewn wooden *Endless Columns* alongside a bronze *Bird in Space* and several polished egglike forms, *c.*1929–30

Brancusi's own photographs of his studio, some of which were published in *Cahiers d'art* in 1929, confirm this hierarchical approach to forms and his methods of juxtaposition. They show that he was a pioneer of the environmental assemblage and the curated presentation of work. The pieces are carefully placed throughout the room in considered relationship to each other. Visitors such as Man Ray testified to the painstaking care that Brancusi took over the arrangement of his work, whether it was in the gallery space, in terms of the selection of lighting and space; in his studio, by constantly reordering the positive and negative pieces within the space to complement one another; or in photography, where he carefully constructed scenarios of light and dark, substance and shadow, smooth and textured, bringing to the work a quality of absolute completeness.[5]

In all of Brancusi's polished pieces, there is the sense of their becoming, of a period of transition and purification under the artist's touch. Nothing is ever finished. And like his various *Endless Column* sculptures and the *Bird in Space* series, the polished works suggest that they will go on reaching towards an eternity. They stretch upwards and away from their crude bases. What Brancusi learned from exploring both Romanian folk carving and African sculptures was that all works carry power – positive and negative. In his sculptures he harnessed both realms of good and evil, playing one off against the other. But rarely is the refined object placed beneath the crude. As in platonic theory, the crude is always the base representing the material world, the negative impression to the positive idealistic image.[6]

Tête qui regarde (1923) and *Tête* (1925) are the early works of Giacometti that are most indebted to Brancusi. They were showcased in September 1929 in the dissident surrealist journal *Documents*, where they were interwoven into Michel Leiris's theme for that issue, a critique of civilization, which ranged through its articles, reviews and illustrations. Like Brancusi's displays, Giacometti's pieces were not just presented in *Documents* but orchestrated by Leiris to reinforce the journal's dissident message (*see page 151*). Their re-presentation in compositions of two or three juxtaposed works created mysterious relationships. The codes for understanding both the works and Leiris's editorial motives in illustrating them were sealed within the obscure poetic and surreal texts alongside the images.

Documents frequently used such juxtapositions in its design and layout. In the same way that Brancusi's pieces were arranged spatially to relate to one another, the make-up of the magazine's pages was integral to an understanding of each issue's theme. *Documents*'s mission was to

DOCUMENTS

**ARCHÉOLOGIE
BEAUX-ARTS
ETHNOGRAPHIE
VARIÉTÉS**

4

Magazine illustré
 paraissant dix fois par an

Erland NORDENSKIÖLD. Le balancier à fardeaux et la balance en Amérique. — Quelques esquisses et dessins de Georges Seurat. — C. T. SELTMAN. Sculptures archaïques des Cyclades. — Georges BATAILLE. Figure humaine. — Carl EINSTEIN. Gravures d'Hercules Seghers (1585-1645). — Michel LEIRIS. Alberto Giacometti. — Chronique, par Georges Bataille, Robert Desnos, Carl Einstein, Jacques Fray, Marcel Griaule, Georges Henri Rivière, André Schæffner.

PARIS, 39. rue La Boétie (VIII)

Cover design for *Documents*, 1929, no. 4

delve deeply into the murkier areas of life to discover other realities that challenged complacent bourgeois ideals and values. Africa and its art were regularly part of this presentation to counter Western norms. Using a form of positive discrimination, black life was revered as an alternative model to relieve the *ennui* of middle-class existence: an antidote to the ailments of civilized society. In *Documents*, Leiris was to write:

> We are weary of those all too insipid spectacles, which are not stiffened up by any form of insurrection, whether potential or actual, against divine 'politeness', that of the arts known as 'taste', that of the brain called 'intelligence', that of life designated by the word 'morality', which has a dusty smell, as though pulled out from the depths of an old drawer.[7]

Edited by Georges Bataille, and with contributors such as Leiris, Georges Henri-Rivière and Carl Einstein, *Documents* contained mainly ethnographic and archaeological features, as well as music and art criti-

cism. Both Bataille and Leiris had studied under the ethnographer Marcel Mauss, famed for his alternative approach to the subject, while from an early age Leiris had also admired the idiosyncratic work of close family friend Raymond Roussel. Such rarefied backgrounds might have been predictive of *Documents*'s bizarre contents.

The journal was formed in opposition to 'official' surrealism after Bataille broke with the movement's leader André Breton in 1929 over political issues. Bataille could never completely identify with surrealism's adoption of a Marxist dialectic. Further, the trend of Breton and his followers towards Communism and the principles of historical materialism, as evidenced in Breton's *Second Manifesto* of September 1929, contrasted with Bataille's challenging of reason and conventional morality.[8] It was Bataille's deconstructive thinking that was at the heart of the debates between himself and Breton, and which caused him to take exception to the 'sur' of surrealism. In particular, his concept of *la bassesse* distinguished him from Breton. *La bassesse* – a low, or base, materialism – challenged the platonic schema, whereby that which is uppermost is ideal, and suggested instead the opposite, 'an ascendance downward', as Rosalind Krauss puts it.[9] Bataille proposed an alternative view of the human where its 'being' is rooted in the mud, and where man's orifices and bodily functions become more important than his thought processes. According to this conceptual inversion, cannibalism, human sacrifice and sadomasochistic acts of violence all serve to validate and valorize the human condition. Bataille's extreme anti-idealism promoted a 'sinister love of darkness and monstrous taste for the obscene' that went far beyond the surrealists' anti-bourgeois manifestos and pranks. Although Bataille situated himself somewhere 'at the side of surrealism', his interests, and the interests of those who supported *Documents*, might be more aptly termed 'sousrealist', a term that better situates their dissident thinking in a sort of abstracted hell somewhere beneath mainstream surrealism.

Like Bataille, *Documents*'s contributors and editors were also mainly ex-surrealists who had broken with André Breton and positioned themselves beyond surrealism. It was the journal's use of the surreal to explore the occult, sadism and other forms of sexual deviance that distinguished it from the type of surrealism interpreted and commandeered by Breton. While Breton's surrealism derived from the sentiments of the writers Charles Baudelaire, Arthur Rimbaud and Stéphane Mallarmé, and the nihilistic legacy of early surrealist Jacques Vaché, *Documents*'s 'sousrealism', with its extremisms, was more closely related to the anarchic sentiments of Dada and the later thinking

of Robert Desnos and Antonin Artaud. Bataille's overwhelming negativism, and his obsession with exploring sexual inhibition, meant that *Documents* came to be labelled as perverse by its opponents. Of Bataille and the dissident supporters of *Documents* Breton wrote in the *Second Manifesto*:

> M. Bataille professes to consider in the world only what is vilest, most discouraging and corrupted, and he invites man to avoid making himself useful for anything specific 'to run absurdly with him – eyes suddenly dim and filled with unavowable tears – towards haunted provincial houses seamier than flies, more depraved and ranker than barbers' shops'. If I relate such remarks it is because they seem to me to implicate not only M. Bataille but also those ex-surrealists who wanted to be fully free to involve themselves anywhere and everywhere.

Documents attracted dissidents such as Georges Limbour, André Masson, Michel Leiris, Roger Vitrac and Raymond Queneau who took exception to Breton's regimented approach to left-wing politics. But as an ethnographic journal, it also attracted support from respected anthropologists like Roger Caillois, Marcel Griaule and André Schæffner. As cultural analyst James Clifford has pointed out, at this time ethnography was still in its infancy, and the boundaries between art and science, and ethnography and surrealism, were more difficult to determine. *Documents* was the playground where these intellectuals could test their ideas in a way that would not have been possible in other journals such as *Cahiers d'art*, whose high-class, high-gloss, commercial format promoted avant-garde thinking to a more mainstream audience. *Documents* was also a glossy review, but with a distinctly subversive agenda that involved humour, satire and a cultural relativism that allowed it to critique bourgeois society and to propose alternatives.

Leiris's own fascination with other cultures and the occult received a shot in the arm following the publication of William B. Seabrook's novel *Magic Island* in 1929.[10] In this book, Seabrook, described by the contemporary French critic Paul Morand as 'perhaps the only white person of that era to have had a real baptism of blood', documented the vodou beliefs and rituals of the blacks in Haiti.[11] *Magic Island* typified the racist texts that sensationalized Haiti's culture after the island was occupied by Americans in 1915. It portrayed Haiti as savage, exotic and mysterious. Haiti, with its political history of defiance, was particularly attractive to the surrealists. In 1804, under the leadership of Jean-Jacques Dessalines, it challenged French colonial rule and became the first black republic, a

William B. Seabrook beside a Haitian vodou altar, from *Documents*, 1929, no. 6

victory that would result in its future struggle for economic and political stability. Seabrook opposed the American occupation and defended Haiti's right to self-determination based on its own folk traditions. Haiti's syncretic mix of Catholicism and African beliefs manifested a sense of the spirit world in daily life that appealed to the surrealists' reordering of reality. Vodou beliefs and practices involving blood rituals, curses and blessings, a pantheon of deities and zombies (the walking dead) matched exotic surrealist ideas about the primitive. Seabrook's method of research would have appealed to Leiris's own approach to ethnography, since it involved adventurous fieldwork, the taking of secret oaths, and living intimately with the Haitians to learn their customs. But, as literary historian J. Michael Dash has discussed, Seabrook seems to have been more concerned with protecting Haiti from cultural contamination than with seeing it develop as a modern nation, since it was important for him that Haiti remain a model for ideas of negro primitivism.[12] The fact that Leiris carried a copy of *Magic Island* for inspiration on the Mission Dakar-Djibouti in 1931 shows how much he admired Seabrook's style.[13] In November 1929, he had reviewed the book in *Documents*,[14] and in an issue the following year he had used Seabrook's photographs of black leather masks to illustrate his own interest in sexual violence, fetishism, disguise and the denial or masking of one's own self, all practices positively associated, in the 'sousrealist' mind, with blackness.[15]

Leiris shared with Seabrook the view that by whatever means of 'mysticism, madness, adventure, poetry, eroticism, the Western duality of mind and body must be destroyed'. He believed that to collapse the boundaries between the real and the surreal worlds required what he termed 'moments of crisis' – sudden revelatory experiences. He described one such experience after seeing a performance of the African-American Black Birds troupe in 1929:

> There are moments that can be called *crises*, the only ones that count in life. These are moments when the outside seems abruptly to respond to a call we send from within, when the exterior world opens itself and a sudden communion forms between it and our heart. From my own experience I have several memories like this, and they all relate to events that seem trifling, without symbolic value, and one might say *gratuitous*: in a bright Montmartre street, a negress of the Black Birds revue holding a bouquet of wet roses with both hands; onboard a ship slowly leaving a quay; snatches of songs whispered at random; the encounter in a Greek ruin with a strange animal which must have been a kind of giant lizard ...[16]

The *Documents* circle's interest in the art of other cultures manifested itself typically through this type of contiguity and its challenge to normal ways of presenting art and life to readers. With other journals such as *Cahiers d'arts*, 'primitivized' works appear showcased, isolated and static.[17] But in *Documents*, the primitivized object was juxtaposed against other equally displaced European forms, bringing a sense of equality to their reappraisal. This format provided a revised context for all the works. Further, *Documents*'s interest in primitive societies went beyond a benevolent patronage. It had a genuine curiosity and admiration for all non-European cultures that could offer alternative lifestyles and philosophies. *Documents* kept up a campaign of subversion that involved the disorientation of the viewer from the known and the familiar and the introduction of 'exotic alternatives' as substitutes.

In *Documents*, there were no 'givens': reality was constantly questioned, and all judgment deferred or deflected onto the viewer/reader. *Documents*'s open-endedness was its most frightening tool. Its celebration of the perverse allowed for creativity previously considered distasteful. Juxtaposition was a powerful weapon of this subversion. Text and image conspired to jolt the viewer to new levels of awareness.

Another idiosyncratic feature of *Documents* was its 'Dictionnaire critique', a regular column that allowed the dissident writers to reexamine words and to offer short essays on their reinterpretation.

'The Black Birds on a steam boat', from *Documents*, 1929, no. 4

Inversion and juxtaposition again played a role in the recoded defini-
tions offered in this 'critical dictionary'. For instance, the offensive act of
spitting is represented as a west African blessing, and the entry on
'Angels' offers an image of a black Angel Gabriel; 'Man' is defined in
term of his chemical make-up, and 'Abbatoirs' are viewed as the present-
day remnants of sacrificial temples. In the spirit of the dictionary, the
word 'denigrate' (or literally 'de-nigerate'), although never considered,
might have been used to describe the function of these essays, since their
writers appeared to take the meaning of a word to its lowest common
denominator, and in effect 'make it blacker'.

Early issues of the journal contained sections devoted to 'Doctrine',
'Archéologie', 'Beaux-Arts' and 'Ethnographie'. From issue four in
September 1929, the inclusion of 'Variétés' introduced Leiris in the new
role of cultural analyst. Through this column, Leiris commented on
current events, jazz, music-hall stars, cinema and photography, along-
side art, archaeology and ethnographic issues. His approach promoted a
reordering of the world away from a hierarchy of 'us and them' towards
a collaged presentation of events and snippets of information that was
democratic but also disconcerting.

The performance in 1929 of Lew Leslie's Black Birds in Paris was a
central theme of the fourth issue of *Documents*, meriting articles, illus-
trations and constant references interwoven with other issues.
Originating in Harlem, the Black Birds were a troupe of black performers
and musicians brought together by the band leader Leslie for a series of
performances at the Moulin Rouge throughout the summer of 1929. This

group, or the original version of it, had enjoyed success in Paris previously when it had toured in 1927, capitalizing on the popularity that Josephine Baker's *La Revue nègre* had created. The female star of the original troupe had been Florence Mills, who had been described as a '*mulâtresse au sang bleu*' and had earned the title '*Marquise*' for her dancing of the charleston. Her untimely death was a serious setback to Leslie's plans for the revue; but in spite of this, and despite the fact that it was obviously a low-budget production, the *Black Birds of 1928* show became the longest-playing black musical on Broadway. Mixed reviews meant that Parisians awaited the arrival of the troupe, now starring Adelaide Hall and one or two last-minute replacements, with both anticipation and scepticism.

As it was, the success of the Black Birds in Paris did not rest on any one star's performance or on the quality of its musical scores, but on the troupe's adaptation of the recently written novel *Porgy* by American author DuBose Heyward.[18] Their dramatization of the book (later reworked into the musical *Porgy and Bess* by George Gershwin) revived *le tumulte noir* in Paris and became something of a cult classic for the dissident 'sousrealists' of *Documents*. Based in the shanty settlements of South Carolina, *Porgy* centres on the lifestyle of a small black fishing community. The main characters of the drama are Porgy, a cripple and a beggar; Crown, a malevolent hardened sailor who very early in the

J. DELAURIER Scene from the Black Birds' production of *Porgy*, from *L'Art vivant*, 1 August 1929

Paul Robeson as Emperor Jones, 1933

narrative commits murder during a gambling dispute; Bess, Crown's woman, a prostitute and drug addict who befriends Porgy; and Sportin' Life, a pimp and drug-pusher. The story reveals events that take place after the murder, the frustrations of the judicial system, Porgy's romance with Bess, and his eventual avenging of the murder by himself killing Crown. Yet, despite Porgy's freeing of Bess from Crown, her return to the low life of drugs and prostitution brings the drama to a close within an air of futility.

The tale, though harsh, was a simple one set in the ante-bellum period when the liberated slaves lived by working the cotton planta-tions or by plying the rivers with their trade. There was little artifice in the narrative; rather, it afforded white viewers a glimpse into the lives of a poor but 'free' black community. Although Leslie's production was described as an 'an all-white creation for an all-black cast', it was not so much a jazz performance centring on the lives of the urban black than, as Gershwin described it, 'a folk opera'. Like other pioneer black theatre productions of the day, such as Eugene O'Neill's *Emperor Jones* (1921) and *All God's Chillun Got Wings* (1924), Paul Green's *In Abraham's Bosom* (1926) and an adaptation of Edna Ferber's *Show Boat* (1926), this production did not self-consciously cultivate white

audiences by 'whitewashing' black subjects. If violence, sexuality and blackness can be seen as major interests of the contributors to *Documents*, then their fascination with the Black Birds' performance of *Porgy* is understandable, for it presented all of these things graphically. The narrative contained two murders, a wake, a moving burial scene, a violent storm, intimations of rape, talk of 'happy dust', and prostitution, all against the backdrop of the Negro spiritual.

The Black Birds' production had a profound effect on the *Documents* circle and dominated the journal's fourth issue in 1929. As part of an essay on civilization, the human figure and voyeurism, Leiris offered a complete analysis of *Porgy* and the adaptation at the Moulin Rouge. It was in the same issue that Leiris wrote about his 'moments of crisis' in a piece on the young Giacometti. In this, he used Giacometti's sculpture as a visual support to his own discursive essay. His juxtaposition of the sculptor's works provoked binary oppositions – male/female, active/passive, black body/white body, victim/violator, savage/civilized – which were consistent with *Documents*'s format. These were thus not merely illustrations but, rather, dramatic photographic compositions that reinforced the text. In one of the images (*opposite*), which features Giacometti's *Homme et femme* of 1929 surrounded by three of his earlier Brancusi-like *Têtes*, focus is placed on the man and woman in the centre. The act is sexual: 'he' is angular, piercing and phallic; 'she' is spoonlike, womblike and crimped. 'Her' stance is weak and ambivalent, yielding here, cowering there, retreating from his plunging, menacing form. The 'moment', whether of crisis or of ecstasy, is one of savage violence. By contrast, the 'heads' that look on represent the civilized. Their sexuality is negated; they are relegated to being mere 'heads that look', solid, minimal and genderless.

Both Bataille and Leiris shared a morbid fascination with death, suicide, sadomasochism, ritual sacrifice, cannibalism and raw violence. Through their writing, they encouraged the reader to forgo inhibitions and to explore the 'darker' side of human nature. For Leiris, Europeans were like Giacometti's *Têtes*: passive spectators to be provoked into participating in life's arena. He believed that the intense excitement he experienced watching *Porgy* came from black culture's savage potency, and should be cultivated. His engagement with the performance, and with other black art forms, thus openly made links between violence, sexuality and blackness, and resurrected negative images of blacks that were at variance with the New Negroes' imaging of themselves, and at odds with ethnography's trend towards promoting a more sensitive and detailed understanding of black cultures.

MICHEL LEIRIS Photographic composition from *Documents*, 1929, no. 4, showing three of Giacometti's *Têtes* surrounding his *Homme et femme* of 1929

In his review of *Magic Island*, Paul Morand, writer, anthropologist and connoisseur of black culture, noted that, like in Haiti, occult practices in America among ex-slaves had not disappeared.[19] If one analyses the responses of the 'sousrealists' to *Porgy*, it is clear that they believed that they were viewing an authentic manifestation of negro occultism. Unlike reviewers of *La Revue nègre* three years earlier, they saw *Porgy* as something more than just sexual titillation and popular entertainment. The musical, because of its concerns with African ancestral belief and local customs mixed with Pentecostal-style evangelism, presented viewers with a spiritual experience that came close to Bataille's concept of *la bassesse*, albeit still within an entertaining format.

Mainstream critical response to *Porgy* was mixed, and it seems that the 'sousrealists' highlighted the production's more sordid aspects for their own ends. Dance critic André Levinson reviewed both the performance and the novel and considered the latter a success because of its 'style' and 'classical quality', and seriously questioned whether a person *de couleur* could ever have written it.[20] Levinson also drew parallels between the black production and performances by the Russian theatre in Paris.[21] Leiris attacked such bourgeois responses with scorn. For him,

primitive expression was not to be corrupted with the European classifi-
cations of 'Art'. *Porgy* operated according to its own logic, distinguished
by magic and spontaneity.

Leiris's refusal (in his own mind) to judge *Porgy* by European stan-
dards of art flouted the concerns of the contemporary black artists of the
Harlem Renaissance, who were aiming to compete within that same arena
on white terms. The concept of the New Negro, for all its naïvety, sought
to deny the very 'savage' that the 'sousrealists' admired. That Leiris and
others like Seabrook could be so insensitive to the political aspirations of
the contemporary black in favour of exploring stereotypes demonstrates
the extent to which they were consumed by their own atavism.

Avoidance of blacks' realities and the perpetuation of certain violent
tropes, were the most disturbing aspects of the *Documents* circle's
agenda. The ethnography of the 'sousrealists' necessitated an interest in
past rather than present cultures, and denied blacks any reality other
than a historical one. Their confrontation with 'the other' required the
stagnation of so-called primitive cultures in order to facilitate their
'sousrealist' contradictions. Further, their ethnographic practice of direct
contact with these cultures was more a concern for self-exploration and
colonial adventure, and was qualitatively little different from colonial
voyeurism. The idea that it was only the white man who travels locked
blacks into the same vacuums created by their pictorial juxtapositions.
The white man's psyche is encouraged to travel sideways, to move
downwards or even to go backwards in search of new realities, but the
black man must stay put.

The sense of being trapped is paramount in the fourth edition of
Documents. In the pages that accompany Leiris's article 'Civilisation'
and André Schæffner's review of the Black Birds, the reader is offered a
series of images of blacks that reinforce the journal's message.[22]
Juxtapositions of the images are made for political reasons and relate to
the 'sousrealist' criticism of France's colonial activity in Africa. Like the
surrealists, the dissidents under Bataille and Leiris promoted the rights
of all people to self-determination, and saw the country's imposition of
French culture on its colonies as a mere instrument to ensure the smooth
running of its empire. Before their break with surrealism, they had
joined Breton in expressing their antipathy towards Western civiliza-
tion, and pointed out the atrocities of France's imperialist rule abroad. In
particular, the 1926 rebellion of the Rif in Morocco became a *cause
célèbre* for all the surrealists. After the split in the movement in 1929,
Breton would take his anti-imperialist stance even further. On the occa-
sion of the Colonial Exhibition in 1931, the surrealists issued a

manifesto entitled 'Ne visitez pas l'Exposition coloniale' ('Stay away from the Colonial Exhibition') and countered the exhibition with one of their own called 'The Truth about the Colonies', which had the Marxist theme 'A people who oppress others cannot be free'.[23] In spite of their disagreements over dialectical materialism, both Breton and Leiris maintained their mutual interest in African and Caribbean politics and their positions on anti-colonialism.[24] Both would support black movements for self-determination, such as negritude, in the coming decades.

Some of this political intent can be discerned within the photographs of blacks in *Documents*. In one pairing (*see page 154*), an image shows a tidy string of naked black adolescents standing to attention beside their chief, forming a miserable anchor to the free-flowing imagery of Bessie Love and her troupe of dancers above. This second photograph shows a group of white women, alluring in their short dance costumes and tap shoes, raising their hands in a gesture suggestive of political and sexual liberty. It is implied that the white women have stolen the freedom of these black youths, and it is suggested that blacks in their 'natural' state cannot be ordered. This is also seen in a picture that appeared on a following page, 'Canaques de Kroua, Koua-oua, côte est', a photograph of an African group in which the native blacks are shown resting easily in the bush. The bold title of the article immediately beneath the picture reads 'Les "Lew Leslie's Black Birds" au Moulin Rouge', a juxtaposition of text and image that implies that the Black Birds are nothing more than savages (these savages?) beneath their urban garb.

Alongside these images, *Documents* presented a curious display of four pictures of blacks in different contexts: 'Petite fille noire à New York'; 'Bonne d'enfant à Nouméa'; 'Mademoiselle Lovzeski'; and 'Sandouli, petit chef de Kanala' (*see page 155*). Viewed together, they form a powerful essay on the black condition, albeit based on an understanding that is flawed and prejudiced. The photographs, taken in different parts of the world, suggest the disparate nature of black culture. It was an essential point to make for whites, who tended to see blacks as a homogeneous group. Yet, there is something troubling about the selection of images that places a judgment on these black people and makes them appear like freaks. All wear the burden of assimilation, and it is ill-fitting and incongruous. They appear alienated not only from their culture but also from themselves.

These images thrive on their 'sousrealist' context because of the ambiguous readings they provoke. But their ambiguity is locked into the same round of established racist presumptions concerning savagery, sexuality and suppressed violence from which the 'sousrealists'

Bessie Love dans le film parlant " Broadway Melody "
qui passera incessamment au Madeleine-Cinéma.

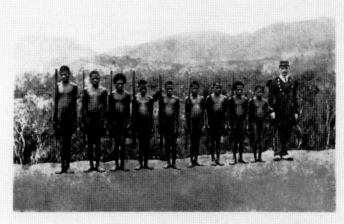

Enfants de l'École de Bacouya, Bourail.
(Albums de photographies de E. Robin, 1869-1871. — Musée d'ethnographie du Trocadéro.)

Page from *Documents*, 1929, no. 4

Phot. Keyston

Petite fille noire à New York.

Bonne d'enfant à Nouméa (Albums Robin).

Phot. Nadar

Mademoiselle Lovzeski.

Sandouli, petit chef de Kanala (Albums Robin).

LA REVUE LA PLUS MODERNE D'EUROPE. - DIRECTRICE :
TITAŸNA. - RÉDACTEUR EN CHEF : CARLO RIM. - SES
COLLABORATEURS : ALEXANDRE ARNOUX - ANDRÉ BEUCLER -
GUS BOFA - PIERRE BOST - MAURICE BOURDET - FRANCIS
CARCO - MARC CHADOURNE - CHARENSOL - BLAISE CENDRARS
LOUIS CHERONNET - RENÉ CLAIR - JOSEPH DELTEIL - ANDRÉ
DEMAISON - JACQUES DYSSORD - MARC ELDER - JEAN
FAYARD - FLORENT FELS - JEAN GIRAUDOUX - HENRY-
JACQUES - MAX JACOB - LOUIS LALOY - LEO LARGUIER -
PIERRE LAZAREFF - GÉO LONDON - HENRI DE MONTHERLANT-
PAUL MORAND - LÉON MOUSSINAC - MAC ORLAN - MARCEL
PAGNOL - JEAN PRÉVOST - THOMAS RAUCAT - CLAUDE
ROLAND - ANDRÉ SALMON - PIERRE SCIZE - PHILIPPE
SOUPAULT - JEAN TEDESCO - ETC...
ÉDITÉ PAR LOUIS QUERELLE - 26, RUE CAMBON.

CARLO RIM Advertisement for *Jazz*, from the first issue of *Documents*, April 1929

were unable to escape. The photographs' juxtapositions reveal a side to *Documents*'s ethnography that focused on the abnormal. The journal used images of blacks, along with Jacques-André Boiffard's erotic and disturbing mouths, anuses and big toes, as part of a pictorial schema to depict altered states and a base low life. To situate blacks within this lower order did little to assist European society's understanding of black culture. *Documents* merely reinforced century-old fears of what blackness signified.

The 'sousrealists' used black culture as a resource to work through and act out their lop-sided view of the world. They consciously mapped out a whole network of ideas under the guise of ethnography. Their favouring of black culture reflected another, more conceptual level of exploitation that was subversive and reflective of their own ideological persuasions. Although oppositional to colonialism, they posited an alternative that was as sinister in its baseness and as misguided in its interpretations. Despite valorizing negatives, *Documents*'s depictions of black people differed little from Brancusi's use of opposites. The magazine used them as coded accessories that undermined rather than enhanced the white subjects they despised. Whether used to enhance or to subvert, the results were just the same: the journal's affirmation of what the 'sousrealists' understood black culture to be hindered rather than helped the New Negro's thrust towards acceptance and equality. *Documents*'s images did nothing for black awareness, or for European awareness of blacks. The New Negro aspired to collaborate in modern art practice; it did not help black culture in any way to be portrayed by 'sousrealism' as 'subversive', rather than subverted.

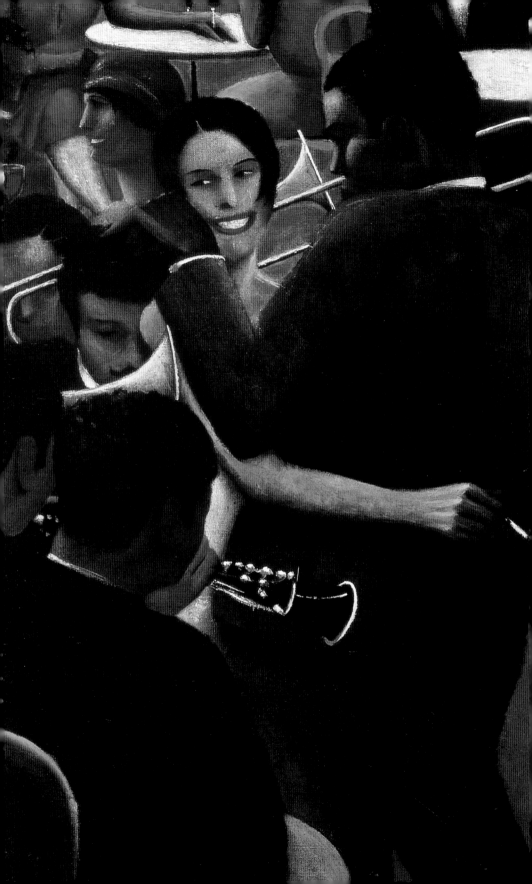

A glimpse into the lives of two significant negrophile personalities of the 1920s – Nancy Cunard in Paris and Carl Van Vechten in New York – reveals their similar interests. It also serves to introduce the African-Americans in Paris and Harlem whom they invited into their social circles. Opinions from Harlem Renaissance personalities such as Langston Hughes and Claude McKay show how complex the relationship between blacks and whites was, and how this affected both groups' shifting sense of identity.

This chapter highlights the literary work of Cunard and Van Vechten, both of whom acted out their fascination with black culture in unique ways, and looks at their personalities, lifestyles and efforts to promote black writers of the Harlem Renaissance. In particular, Cunard's editing of the anthology *Negro*[1] and the critical responses to Carl Van Vechten's controversial novel *Nigger Heaven* are considered.[2] The chapter examines the milieu in which both these books were produced, and their impact on Harlem's and Paris's avant-gardes.

> This is the first time that such a book has been compiled in this manner. It is primarily for the Colored people and it is dedicated to one of them. I wish by their aid to make it as inclusive as possible.

Nancy Cunard was certainly inclusive in her request in 1931 for contributions to *Negro*, the anthology of black culture first promoted under the working title 'Color'. The book was inspired by Cunard's personal involvement with the black musician Henry Crowder, and by the excitement generated by the Harlem Renaissance and negrophilia. Swept off her feet by the craze, Cunard wanted to document the history and achievements of the black race. The idea for an anthology first came to her in Paris while she was enjoying a self-imposed exile from her native England, flouting family censure and eventual disinheritance. She conceived *Negro* as a cosmopolitan project involving blacks throughout the diaspora, and saw it as a unifying statement about black cultural nationalism. The book was to be the first publication to voice freely the

perspectives and ideologies of diaspora blacks and Africans. In particular, it would showcase the work of Harlem artists and intellectuals, whom W. E. B. Du Bois called 'the talented tenth', or whom *Messenger* editor Wallace Thurman more scathingly called the 'niggerati'. There were to be contributions from whites, of course, and Cunard promoted the publication as a collaboration between 'the two races'. The proposed anthology was very much in keeping with the sentiments of the era, already expressed by pan-Africanists like Marcus Garvey who were calling for unity among black nations, a time when Harlem Renaissance intellectuals were keen to explore their African and diaspora heritage. The idea also took hold at a time when those spearheading black America's cultural reformation were becoming more race-conscious as a result of their post-emancipation shift to the northern states of America and their voluntary migrations to Europe in the postwar era.

Harlem may have popularized black culture, but it was Paris that nurtured and sustained it. Postwar Paris, flush with its over-valued franc and no prohibition, hysterically partied away its melancholy. Rich Americans came to Paris for the 'season' of fashion and horse-races; intellectuals and artists like Scott and Zelda Fitzgerald and Ernest Hemingway came to muse in the atmosphere of Montparnasse and Montmartre. Blacks were the entertainers who helped Paris to forget its wartime memories. It was the city's eclecticism that afforded black performers, writers, artists and intellects an equal footing alongside the Russian and Swedish ballets, circuses, music hall, theatre productions and the more dramatic negro *soirées* of the surrealists.

Montmartre, renowned for its nightlife, was the area to which most blacks gravitated. This was the quarter for clubs that featured both jazz and Latin music, such as Zelli's, Le Grand Duc, Bricktop's, Chez Florence and Chez Joséphine. Initially, its black community were musicians, but during the 1920s the community grew to accommodate writers and artists. Most of Montmartre's blacks were African-Americans, but there were also ex-soldiers from Africa and the Caribbean. By 1929, columnist and historian Joel A. Rogers could write:

> The boulevard de Clichy is the 42nd and Broadway of Paris. Most of the nightlife of Paris centers around it, and most of the colored folks from the States, too. If you hear that some friend from the States is in Paris, just circulate around this boulevard from the Moulin Rouge down rue Pigalle as far as the Flea Pit, and it's a hundred to one shot you'll encounter him or her, at least twice during the night.

Most of the colored folk live in this neighborhood. There is a surprising number of them, and it's increasing every year. Just now with the 'Blackbirds' at the Moulin Rouge, this section of Montmartre reminds you more of Harlem than ever.[3]

When blacks were not entertaining whites they entertained themselves at the Bal Nègre, a Caribbean club on the rue Blomet in Montparnasse that featured orchestras from the French islands. Rogers, discussing the atmosphere of this Caribbean dance hall, noted the difference between the African-American and the Caribbean blacks in manner of dress, dance and speech. Bal Nègre provided a space in which both sets of blacks could interact, and where African-Americans could learn a little more about the diversity of the African diaspora. Nevertheless, black life in Paris could be alienating, particularly outside the entertainment field. Blacks' socializing with a wider French society did not extend beyond these nightclubs, and unless they came from well-to-do backgrounds, they could get only the lowest-paid, low-skill jobs for support.[4]

PALMER C. HAYDEN *Nous Quatre à Paris*, c.1930

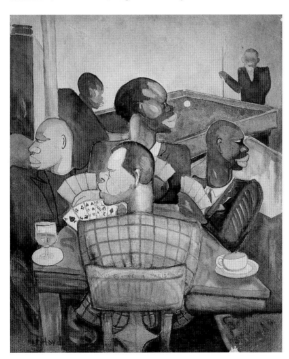

French art historian Catherine Bernard has already questioned France's policy towards blacks, both at home and abroad, seeing it as more conservative than might be presumed.[5] Such a reappraisal also informs an understanding about the black artists who favoured a Parisian lifestyle. Most were privileged even before they came to Europe. Black artists such as Lois Mailou Jones, Palmer C. Hayden and Henry O. Tanner were more inclined towards a conventional academicism, despite Paris's reputation for modernity. African-American poets demonstrated similar restraint. Writers like Countee Cullen, Claude McKay, Langston Hughes and Alain Locke framed their ideas about the New Negro within Harlem's modernist experience. Some, like Hughes and McKay, came to Paris speculatively, taking jobs beneath their status just to get a foothold there. Once settled, they aimed to be accepted as artists and to gain parity for their culture in the city's mainstream. Claude McKay describes in his novel *Banjo*, through its protagonist Ray,[6] how, anxious for work, he settled for a job modelling naked for white female art students, and his humiliation when questioned whether as a 'savage' he could be trusted to behave in the studio. Langston Hughes's baptism to life in Paris was similar. When he enquired about work he was told by a fellow-black, 'Less you can play jazz or tap dance, you'd just as well go back home'. Hughes eventually found a job as a doorman at a club on the rue Fontaine that later became Chez Joséphine, owned by Baker. From there, he moved to Le Grand Duc and worked his way up from dishwasher to cook. All the time, he was writing and networking. Later, in his novel *The Big Sea*, he describes a lunch meeting with Thomas Munro and Albert C. Barnes. They were 'doing the Louvre' for a study of modern art. Hughes knew nothing about art but was grateful for the meal and an opportunity to seek patrons.[7]

The avant-garde that best accommodated and patronized New Negro interests was itself in conflict with the mainstream values with which most blacks identified. Claude McKay, in his autobiography *A Long Way From Home*, mused on his first meeting with Carl Van Vechten, when the patron, so doped up and disappointed that McKay was only a soft drinker, abandoned him to chase a truck-load of carrots for which he had developed a sudden passion.[8] Many of the European artists, collectors and dealers who fraternized with blacks patronized and cultivated a shadowy world of nightclubs and bohemianism, which they assumed blacks enjoyed. Their intellectual interests were informed by a wayward surrealism, later more respectably clothed in ethnography and anthropology. Most promoted a romanticized exoticizing and stereotyping of the black image linked with notions of rejuvenation of

the white race through devolution and atavism. The needs of this bohemian subculture inevitably compromised New Negro high ideals, in which 'Back to Africa' signified progressive rather than regressive sentiments. The agendas of the New Negro and the Parisian negrophiles were therefore diametrically opposed.

This gulf is best seen in Cunard's relationship with the black musician Henry Crowder. In 1928, Cunard left her surrealist lover Louis Aragon for Crowder, whom she had met in a nightclub. He immediately became a mascot representing Cunard's interest in Africa and blacks. For negrophiles like Cunard, Crowder's presumed racial purity was important to reinforce her own identity as a radical. As biographer Ann Chisholm says about Cunard's attitude to Crowder:

Nancy Cunard and Henry Crowder at the Hours Press, Paris, in 1930, from *Negro*

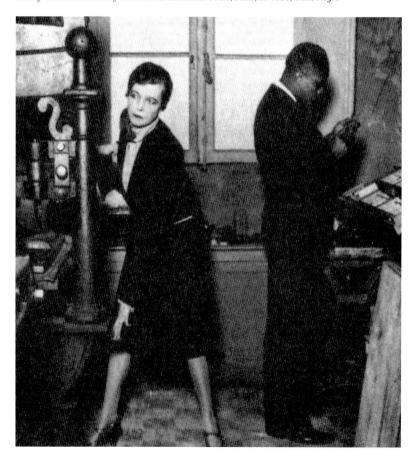

He was patient, in a mildly embarrassed way, with Nancy's often express wish that he had a blacker skin, or that he behave in a more primitive exotic manner. 'Be more African, be more African', Harold Acton remembers Nancy saying to Crowder one evening ... 'But I ain't African, I'm American', Crowder replied mildly.[9]

Crowder had aspirations to be more than a piano player with Eddie South's Alabamians; he was also a talented writer, as demonstrated by his two contributions to *Negro*: 'Where color prejudice is not a creed', which discussed his freedoms as a black man in Paris, and 'Hitting back', his memoirs of racism in the American South. He was wise enough to

Nancy Cunard in 1930 with her Hours Press books, from *Negro*

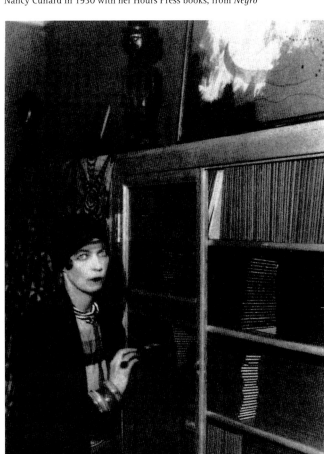

CONTEMPLATING—Miss Nancy Cunard, daughter of a titled Briton, studying the physicology of the coloured race. Our cartoonist shows her secretary, Mr. Colebrooke, supplying her with "dope" while she collects local colour.

Cartoon of Cunard in Jamaica, from the *Daily Gleaner*, 1932

understand the folly of Cunard's zeal, and challenged her perceptions of black people and racism by providing her with copies of the black newspapers *Crisis* and the *Liberator*. During their research for *Negro*, he refused to accompany her on her trip through America because of the race riots that a black man travelling with a white woman might trigger. Crowder's instincts were correct: when Cunard went ahead with another escort, A. A. Colebrooke, the fact of their travelling together was met with hostility in both the United States and Cuba. Cunard was forced to leave Havana because of public harassment.

The press hounded Cunard throughout her trip. It was from a newspaper that she learned of her disinheritance from the Cunard family because of her affair with Crowder. The *New York Times* also maliciously reported other casual relationships between her and black men such as the actor Paul Robeson. In Jamaica, the *Daily Gleaner* cartoonist sketched Cunard studying 'the physiology [*sic*] of the coloured race', while her black male secretary is 'supplying her with "dope"'. Cunard did not flinch. No stranger to limelight, she used these controversies to her advantage, preparing her own press releases and giving interviews. However superficial her relationships with black men were, the consistency with which she stuck to the task of *Negro* reflected a genuine need and concern to identify with and support blacks.

Sterling Brown

Arna Bontemps

Thomas Fortune Fletcher

Georgia Douglas Johnson

Nicolás Guillén

Donald Jeffrey Hayes

Carrie Williams Clifford

Jonathan Brooks

Langston Hughes

Countee Cullen

Walter Everett Hawkins

NEGRO POETS

258

'Negro poets', a page from *Negro*

When colleague Alfred Cruickshank questioned why she devoted herself to fighting for racial equality, she responded poetically:

> You ask: 'Why love the slave.
> The "noble savage" in the planter's grave,
> And us, descendants in a hostile clime?'
> Cell of the conscious sphere, I nature and men,
> Answer you: 'Brother ... instinct, knowledge ... and then,
> Maybe I was an African one time.'[10]

Cunard's sentiments evoke ideas of latent 'primitivism' popular in artistic circles at the time. Rousseau's noble savage, Darwin's evolutionary theories and Lucien Lévy-Bruhl's *la pensée sauvage* coalesce into poetry that advocates nature, biological regression and reconstructive history to promote the African. In her writing, Cunard prefers to use the word 'black' rather than 'coloured', and frames blacks in terms of Africa and nature, as opposed to America and urbanity.

With the assistance of Crowder, Nancy initiated the *Negro* project in 1929. It was to be her consuming passion for the next five years. The publication was plagued with difficulties throughout its gestation. Lack of funds, racial conflicts and suspicion from both the black intelligentsia and white conservatives dogged its progress. Despite this, *Negro* was finally published in 1934 with a print-run of a thousand copies. The book pulled between its covers contributions from a wide black community that had not been united since Marcus Garvey and the Universal Negro Improvement Association (UNIA). Prominent diaspora blacks, such as W. E. B. Du Bois, Alain Locke, Langston Hughes, Zora Neale Hurston, James W. Ford and Marcellino Bottaro, among many others, all made significant contributions. Similarly, members of Cunard's intellectual and artistic circle, such as René Crevel, Raymond Michelet, Samuel Beckett and Cunard's ex-lover Ezra Pound, wrote about black culture. Articles about the condition of blacks in Africa, North and South America, Europe and the Caribbean jostled with reviews of black music, poetry and the arts, and black history. While Cunard promoted the publication as representing a collaboration between 'the two races', the majority of its contributors were of African descent. Many publications had examined black society and culture from a Western perspective: *Negro* was the first to harness the black 'voice' so directly.

Despite its 870 pages, *Negro*'s content fell short of Cunard's original expectations. She had envisaged a tome as significant as Harriet Beecher Stowe's *Uncle Tom's Cabin*, one that would bring about the complete

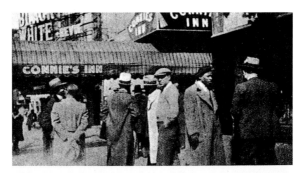

Connie's Inn, 7th Avenue, in the heart of Harlem, a smart Negro night-club, which panders so entirely to the prejudice of its white clientèle that coloured people are actually excluded as guests ; the only Negroes inside are, of course, menials, and the coloured entertainers. No better example than this of the poison of Jim-Crow carried into the very centre of the Negro town ; an example, too, of the incapacity of American whites in keeping away from the despised "niggers"

An illustration and caption from *Negro*, typical of Nancy Cunard's campaigning political and educational agenda

emancipation of blacks in the New World. *Negro* would be entirely doc-umentary, both historical and contemporary, providing information about life in other parts of the diaspora. It was to be an ethnographic document initiated by her but shaped from the black perspective. What Cunard actually collated was a text that in essence bore all the markings of a popular genre, the travel journal. *Negro*'s geographical layout, disjointed and fragmentary discussions, and pseudoscientific posturing married this publication to similar efforts by colonialists, from Winston Churchill's *My African Journey*[11] or Harry Johnston's *Negro in the New World*[12] to Michel Leiris's *L'Afrique fantôme*,[13] the fantasy journal of his Dakar-Djibouti expedition.

Much of *Negro* is stamped with Cunard's editorial hand. It is a selec-tion gained from her travels and networking, rather than a reflection of a pan-African network. Despite Cunard's tireless appeals for fresh and definitive articles, the material collated was more personal and anecdotal than global. *Negro*'s eventual unevenness was an indicator of Cunard's ambition and frustration. Politicized material appears to have been lacking, and where gaps existed Cunard tried to fill them. In these 'commissioned' articles Cunard's bias against racial injustice is evident. Although not a communist, she was a sympathizer and an advocate of working-class solidarity to effect change for blacks. As a result, she included a section entitled 'Negroes and communism', and paid equal

attention to the most current black injustice of the day, the Scottsboro case of nine black boys from Scottsboro, Alabama, who had been sentenced to hang for raping two white prostitutes. Through *Negro*, Cunard launched an appeal to raise funds for the boys' third retrial. The book also included a tract by the surrealists entitled 'Murderous humanitarianism' and signed by André Breton and a number of his communist followers, which catalogued some of the atrocities and indignities of European imperialism, particularly with regard to the African race. In this respect, *Negro*'s scope reflected Cunard's concerns even more than those of her black contributors. In the same way that she had set out to educate Crowder about his African heritage, Cunard's dual mission was to communicate and to promote her radical left ideas to blacks in the New World. Thus, *Negro*'s agenda was set, fashioned and delivered by Cunard.

A campaign poster from the 'Negroes and communism' section of *Negro*

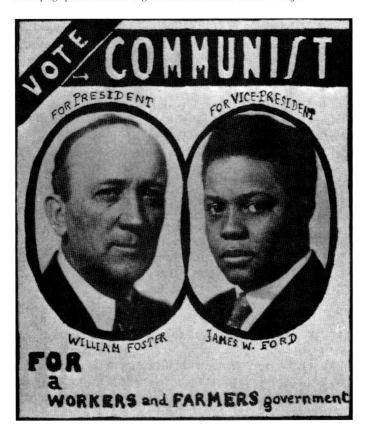

As a negrophile, Cunard shunned white company during her research trips. While in America she caused great distress and discomfort to her black hosts by insisting that she lodge with them. Similarly, in Jamaica, she was quick to distance herself from the local white plantocracy and to create an image of herself as 'a woman of the people' and defender of black causes. Writing in *Negro* about her trip to Jamaica, she makes much of her contact with what she calls 'people of the soil', while emphasizing her avoidance of Jamaica's white expatriates and tourists, claiming that she met 'not one white person' during her whole stay. Why Cunard chose to play down her introduction to white Jamaican society one can only speculate. She concludes her article about the trip by summing up the Jamaica she saw from her encounters with a beggar, a mulatto busher and some diving boys:

> This is the Jamaica I saw. It culminates into a certainty that comes like a voice out of the soil itself. This island is the place of black peasantry, it must be unconditionally theirs. It belongs undividedly and by right to the black Jamaican on their land.[14]

Cunard's agenda was different from that of her contributors. They sought mainstream acceptance and upward mobility. Alain Locke saw the New Negro as urbane, exposed to Western culture, and 'a conscious collaborator and participant in American civilisation'. Even the black separatist Garvey tempered his rhetoric to welcome Cunard when she visited Jamaica (*opposite*). He called his 'mental companionship' with Cunard a 'noble company of minds', in league with other historical thinkers such as Cicero, Spinoza, Darwin, Theodore Roosevelt and Booker T. Washington. Despite his reputation for fiery rhetoric, Garvey's welcoming speech was measured and accommodating, even laudatory of the white race.

But Cunard was unrelenting. She advocated an Africanicity that could rejuvenate and insulate itself against the sterility of modernity. Like many negrophiles influenced by Lévy-Bruhl's thinking, she believed that culture was determined by race and environment and that blacks belonged to a primitive chaotic order rooted in nature that needed to be maintained for their cultural authenticity. It was their *joie de vivre* and connectedness with nature that could be used to revitalize white civilization. Even within Cunard's own form of positive discrimination, she idealized and stereotyped black vitality and the 'shoeless state'.

Similar criticisms were made of Carl Van Vechten and the image of blacks portrayed through his controversial novel *Nigger Heaven*. Like Cunard, he sensationalized black life to enhance his own pleasure with

'Jamaica welcomes Nancy Cunard', from the *Daily Gleaner*, 1932

it. He also immersed himself in black culture to the exclusion of his white friends. That, perhaps, is one reason why he never collaborated with Cunard, with whom he shared such close interests.

Carl Van Vechten was to the New York scene what Nancy Cunard was to Paris. Like Cunard, he came from a wealthy background and moved easily between the *bon vivant* circles of New York, Paris and London. Between 1906 and 1913, he was the music critic for the *New York Times*, after which he became a freelance writer renowned for his knowledge of jazz and popular black culture. His passion for blacks was in fact triggered by jazz, in particular Gershwin's *Rhapsody in Blue* (1924). Like Cunard's obsession with all 'things African', Van Vechten would write that everything for him was '*jazz ... toujours jazz!*'[15]

Van Vechten's interest in blacks peaked in 1925–6, when, also like Cunard, he became obsessed with promoting black culture. He wrote to a friend, 'If I were a chameleon my colour would now be at least seal-brown. I see no one but Negroes.' In the grips of this rage, he decided to channel his interest into writing a negro novel based on black life in Harlem, and early in 1926 he wrote, 'I shall start my Negro novel. I have passed practically the whole winter in company with negroes and have succeeded in getting into most of the important circles.'

If anything, important circles seemed to revolve around Van Vechten. With his flamboyant, camp style and connoisseur's knowledge of literature, theatre and the arts, both blacks and whites courted his

company. He offered informal tours of Harlem's nightspots, and started charleston classes for dilettantes who, like himself, wanted to learn the new craze. A prolific writer, he counted among his circle of pen mates the publishers and close friends Alfred and Blanche Knopf, the writers Ronald Firbank and Fanny Hurst, and Gertrude Stein, then living in Paris. Blacks who favoured his company were the writers Langston Hughes, James Weldon Johnson and Countee Cullen, and Paul Robeson, all young New Negroes of the Harlem Renaissance. Amongst these blacks, Van Vechten was considered a mentor and patron, and was the host of great parties in his West 55th Street New York residence, where both black and white intelligentsia and entertainers could mix easily, free from racial restrictions that constrained the rest of mainstream America. James Weldon Johnson claimed that 'in the early days of the negro literary and artistic movement, no one in the country did more to forward it ...'.[16] It was Van Vechten, writing in the *Herald Tribune*, who first coined the term 'negro renaissance', thereby giving the movement its name.

Much of Van Vechten's writing projects the same intimate interest in, and desire for, blackness that is expressed in Cunard's writing and that was latent in the Parisian surrealist circles. His interest in Freud, Stravinsky and Satie came directly from Europe, and fitted easily with New York's Greenwich Village scene and its budding bohemian tendencies. His modernist sensibility was finely tuned to trends in avant-garde Paris, and he was quick to write about and to introduce new ideas. But Van Vechten was no revolutionary; he was a dilettante who valued his position in midtown artistic circles and drew the line at communist sentiments spouted by protégés like Langston Hughes. Always the gossip, he informed a friend:

> Did I write to you that Gertrude Stein gave a party for Paul and Essie [Robeson]? And Hugh Walpole writes me that he likes Paul better than almost any American he has ever met. And the *Revue nègre* in Paris is a sensation and having packed the Champs-Élysées for six weeks has moved to another theatre ... Josephine Baker, the leading woman, is now the best-kept woman in Paris with a house on the avenue Boulogne! She was a chorus girl in the original production of *Runnin' Wild*. Well, life is dramatic.

Characteristically, Van Vechten's fantasies were phrased in humorous terms lost to the more serious Cunard. James Weldon Johnson recalls that Van Vechten's favourite portrait was a caricature of himself in 'black face' created by Miguel Covarrubias, and Van Vechten wrote to Gertrude

a prediction
to Carl from
COVARRUBIAS.

MIGUEL COVARRUBIAS *Carl Van Vechten as a Negro*, date unknown

Stein saying that, 'New York has gone almost completely native and soon we'll be all mixed up, but those that are born already can never be any darker or lighter'. By 1927, he could write to Langston Hughes, 'You and I are the only two colored people who really love niggers.'

All these sentiments were to culminate in Van Vechten's writing *Nigger Heaven*. The novel looked at the many aspects and characters of Harlem life. It challenged white stereotypes of blacks and presented a cast of personalities that suggested Harlem's diversity. Despite its many characters, the story revolves around a few central figures: Byron the poet; Mary Love, a pretty but prudish Harlem librarian; Scarlet Creeper and Lasca Sartoris, male and female prostitutes, whose 'sportin' life' frustrates the already constrained courtships of the genteel Byron and Mary; finally, there is Randolph Pettijohn, a 'new-money' negro who has no education but is resolute in winning Mary's affections. The story carries the reader through the various anxieties and concerns of these characters. It highlights the pain, frustrations and contradictions inherent in being successful in a black community and the characters' concern for 'passing' as white in order to succeed in a whiter setting. It also presented the wilder and more sordid side of life in Harlem, with its drugs, pimping and brawling. Although there is no clear moral theme to the book, it is the poet Byron who falls into the hands of the police after a debauched affair with Lasca and an attempted murder of Pettijohn, thereby giving victory to the tale's wilder and more unsavoury characters.

From the outset, Van Vechten knew that the novel would create concern. He kept its contentious title quiet, but was secretly excited by it. When the book was eventually published in 1926, he seemed to glory in the uproar. He wrote, 'The *NY News* (colored) says that anyone who would call a book *Nigger Heaven*, would call a Negro Nigger. Harlem, it appears, is seething in controversy.'

Indeed, Harlem seemed to be split in its response to the book. Many of Van Vechten's literary friends, like Charles Johnson, James Weldon Johnson, Walter White and Langston Hughes, welcomed it as an artistic *tour de force* and warmed to its social realism. Others, like W. E. B. Du Bois, considered it 'an affront to the hospitality of black folks and to the intelligence of whites'. Most accused Van Vechten of sensationalism that took little account of the subtler aspects of black life. Aside from the title, many of Harlem's intelli-gentsia felt betrayed and were hurt at the novel's underlying theme, that their New Negro status was cultural posturing and would cost the race its vitality.

The issue at stake was how blacks wished to define themselves in the face of white stereotyping. Many black intellects were disquieted by the white vogue for blackness. They recognized how frivolous and temporal it was, and the extent to which their culture was being admired for all the 'primitive' qualities from which they wished to be distanced. A troubled Langston Hughes expressed his concern in *The Big Sea*, and noted how distortions in black artistic practice were developing because of blacks' interaction with whites. He remarked that the Lindy Hoppers at the Savoy Hotel were including absurd acrobatic turns in their dance routines for the entertainment of whites, and that black writers were 'over-colouring' their material for white amusement. Others saw white patronage as a useful vehicle to gain acceptance into mainstream artistic circles, and were willing to make compromises for this. Locke's New Negro model was a useful halfway house that conformed to mainstream values but also allowed for black self-hood. However, the tendencies of the 'niggerati' towards a cultural nationalism, whereby they gained status and recognition by promoting their artistic difference, meant that their battle for black causes was limited to an intellectual arena that avoided larger racial debates about political status and power for African-Americans.

Not all of Harlem's black intellectuals agreed with this middle-of-the-road approach. Many were attracted to more hard-line politics like Garveyism's black separatism and Du Bois's 'race assertiveness', part of a more universal communist ideal that circumvented race in favour of class struggle and worker's revolution. The poet Claude McKay tended towards this camp and considered himself an outsider from the Harlem Renaissance group. He was at his most creative and comfortable while travelling in Europe and Africa, away from the 'niggerati' milieu. In *A Long Way From Home*,[17] he wrote contemptuously of his New Negro colleagues in Paris, who compromised their blackness for the sake of patronage, describing Alain Locke as, 'a perfect symbol of the Aframerican rococo in his personality as much as in his prose style, he was doing his utmost to appreciate the new Negro he had uncovered'.

The problem for artists like McKay, Langston Hughes and Paul Robeson was how to cross over into mainstream artistic circles while maintaining their integrity and commitment to the black cause. Their ability to do this required what Paul Gilroy calls 'a double consciousness', a more sophisticated and knowing version of Frantz Fanon's 'masking', where one consciously navigates the two worlds of black and white modernity. McKay, Hughes and Robeson were three artists who successfully negotiated the two worlds, but not without censure

and vetting from both sides of the divide. McKay received harsh criticism of his novel *Home to Harlem* (1927) from the negro intelligentsia because it resented his representation of poor blacks at a time when it was trying to promote more positive cultural images. Hughes's 'communist poetry' was seriously censured by Van Vechten, who called it 'propaganda' and advised the Knopfs not to publish it. Robeson, despite his success in the play *Emperor Jones*, found himself cast in a role that, as Jeffrey C. Stewart shows, imprisoned him in a primitive past. Whether as 'a noble savage in New York and then as a savage buffoon in London', Robeson's roles fed into white and black romantic needs that eulogized the Negro but did little to further his own skills as a modern actor.[18]

To have been a black artist in the 1920s in Paris or Harlem must have been an intoxicating experience. Artists experienced a sudden shift of fortunes and were jettisoned into a world of parties, high culture and aristocracy. Many were seduced, and believed that their sudden rise to popularity would go on for ever. Those like Langston Hughes who were wise to the transience of success and the temporal nature of white patronage paced themselves through the partying. He warned of the vogue's fragility and wrote, 'I was there. I had a swell time while it lasted. But I thought it wouldn't last long. (I remember the vogue for things Russian, the season the Chauve-Souris first came to town.) For how could a large and enthusiastic number of people be crazy about Negroes for ever?' Even Van Vechten at the height of the Negro craze in 1925 could write, 'Jazz, the blues, Negro spirituals all stimulate me enormously for the moment. Doubtless, I shall discard them too in time.'

Carl Van Vechten's *Nigger Heaven*, like so many novels of the Harlem Renaissance, spoke about the issues of the day. It remains as a useful marker of the many questions over which blacks and whites agonized during those years. Though her relationship with Henry Crowder did not last, Nancy Cunard's passion for black politics did. She sustained her work on *Negro* through the stock-market crash of 1929 and the depression years that followed. The publication of the book in 1934 stands as the last significant literary event of the Harlem Renaissance years. Despite Cunard's overbearing style and strident role as its editor, the voice of diaspora blacks in *Negro* rings out as clear and as true as if it had been written today. That this single most important source of information regarding blacks at the turn of the decade exists only because of Cunard's efforts is both an irony and a testimony to the negrophiliac relationship.

ARCHIBALD MOTLEY *Blues*, 1929

White self-interest under the guise of patronage often detours blacks from self-knowledge and self-awareness. Black voices of the 1920s demonstrate the complexities that result from that displacement. Blacks still live those complexities daily; and occasionally they impinge on white society. European negrophiles, in embracing black people, partic
ipated in a very difficult relationship; but they could not accommodate the blacks' modern aspirations. Then, as now, black people are an old and weary race looking for what Langston Hughes calls 'a house in the world, where the white shadows do not fall'.[19]

This book has looked at how Paris's white avant-garde perceived and engaged with black culture in the 1920s. In doing so, it has brought a different perspective to the relationship between the two parties. Traditional European art history considers the black model via the white gaze. *Negrophilia* has tried to address this historical imbalance.

Too little has been written about how the avant-garde's relationships with 'others' complemented their outsider status. The more this is examined, the more it becomes clear that their debates about blackness were really about whiteness and about providing Europeans with a new sense of direction. They partied briefly with blacks in the 1920s, but then pulled away because there was little to sustain their relationship. Blacks and whites shared the same dance-floor, but little else. Images of blacks and whites together in that era show them dancing, dancing and only dancing. So it is not surprising that by the early 1930s, negrophilia was on the wane. Significant markers at the end of that relationship were the downturn in the market for *l'art nègre* after the crash of 1929; the return of the Mission Dakar-Djibouti in 1931; the formalizing of the African collection in the new galleries of the Musée de l'Homme between 1933 and 1934; and the eventual publication of Cunard's *Negro* in 1934, when black writers Claude McKay, Langston Hughes and others sidelined the Harlem Renaissance for a clearer commitment to left-wing politics. Beyond this date, Paris's avant-garde would become preoccupied with the primitive in other aspects of modern life, such as G. H. Luquet's studies of childhood,[1] Hans Prinzhorn's research of the mentally ill,[2] and ideas about latent primitivism in proto-Fascism.[3]

The jazz age has often been defined as temporal and sensational. Terms such as 'rage' and 'mania' merely reinforce its irrational qualities and links with madness. Yet, modernity rather than madness was the central theme of the complex network of ideas underlying the period. Industrialization; technological innovations that impacted radically on travel and communication; migration to urban cities in the United States and Europe; imperial destiny; social and spiritual dislocation after the

First World War; post-emancipation development of cultural national-
ism within black diaspora communities; and white revolutionary and
transgressive ideas about civilization – all are factors that counter sim-
plistic accounts of the so-called 'crazy years'.

Young whites and blacks caught up in these changes struggled to
redefine their lives in a new century. White avant-garde artists, abhor-
ring the barbarity, alienation and mechanization of the First World War,
redefined themselves as modern primitives and looked to other cultures
for a simpler lifestyle. Their recognition of black culture allowed them to
cultivate ideas of the primitive within a contemporary setting. They
believed that blacks represented the remnants of pre-civilized society –
contemporary primitives – and they promoted black culture as an alter-
native to Europe's bourgeois values and conservatism. Blacks were seen
as dynamic, non-conformist and subversive. Whether perceived as
African or African-American, primitive or modern, blacks provided
other models for living. The avant-garde's courting of black culture was
a means to the end of rekindling their own primitive states. Black culture
facilitated their regression to the primitive within.

These ideals are captured poignantly in *Cain*, a film released in Paris
in 1930 which provides a useful marker at the end of the decade for
discussing how ideas about the primitive were to shift away from black
people during the 1930s towards an exploration of the Western self.[4]
Cain was created and directed by Léon Poirier, a former member of the
Citroën expedition with Georges-Marie Haardt and director of the
La Croisière noire film that had been a big success throughout Europe.
When the 'La Croisière noire' journey ended in Madagascar, Poirier was
so entranced by the island's geographical and cultural differences from
Africa's interior that he decided to return there to make a film. From the
outset, Poirier was clear that *Cain* would be completely different from
the trite, commercial films made in Hollywood. It would be what Poirier
called 'living cinema', filmed outdoors rather than in a studio, and it
would have only three stars – 'a man, a woman and nature'.[5]

The film tells the story of a modern man, Cain, who jumps ship, ends
up marooned on a tropical island off the coast of Africa, and returns to
an idyllic existence living simply, close to nature, with a native woman,
Zouzour. It is a story of regression, not dissimilar from the artist Paul
Gauguin's own experiences a few decades earlier in Polynesia. The par-
allels between the film's narrative and the last years of that artist's life
are striking, but so too are its connections with Jean Toomer's novel
Cane, published in 1923. In the case of *Cane*, however, the author and
the book's characters are black. Both stories share resonances of the bib-

PAUL GAUGUIN *Where do we come from? What are we? Where are we going?*, 1897

lical story of Cain, historically perceived as black, who was banished by God to the east of Eden for killing his brother. Both narratives explore Gauguin's existential questions 'Where do we come from? What are we? Where are we going?',[6] and both illustrate an inner search for truths involving a return to the roots of man's existence. But it is significant that whereas Toomer's characters must return to the American South to face the painful reality of slavery and to reclaim their home there, Poirier's Cain finds his home in Africa, the cradle of civilization. In the film, the idea of 'Africa' provides a haven where whites can live a primitive existence, even in the modern world. At the end of the film, when Cain gains the opportunity to return to his old life, it is the call of his woman and nature that persuades him to stay and to reject civilization.

The first scenes of *Cain* are set on a ship whose officers, passengers and motley crew below deck represent for Poirier a microcosm of modern society with all of its inequalities. Poirier turns the ship into a 'floating studio', and, as Sergei Eisenstein had earlier done in *The Battleship Potemkin*, he uses the brutish noise of the vessel's engines, its oil-smeared crew, and its sweaty and steamy atmosphere to suggest the harshness of modernity's machinery on humanity. He contrasts these scenes with those of his paradise island, where he captures the sound of its birds and gentle breezes, and nature's resplendence. Poirier's choice of an island, rather than the mainland, as a setting for *Cain* is significant. The island's exotic qualities and opportunities for isolation and exploration of the self suggest that Cain is seeking to escape from reality, be it Western or African.

In spite of *Cain*'s stance against modernity, there is little reflection on the extent to which the whole production stemmed from a film

'Cain carrying Zouzour', a scene from *Cain*, from *L'Art vivant*, 15 November 1930

industry that was entirely modern. Throughout his journal of the
film crew's work on the set, Poirier remarks on this reliance on innova-
tion and technology, which is evident in many of the photographs that
show the movie in the making. Whereas Poirier is sufficiently perceptive
to use a ship, or what Paul Gilroy has called 'a living, micro-cultural,
micro-political system in motion',[7] to represent Western civilization, he
fails to see how the trappings of his own culture still invade life on the
island. The disparity between Poirier's pride in his instruments of civi-
lization and a complete denial of modernity in *Cain* is indicative of a
fundamental irony within contemporary debates about primitivism and
blackness that required a critical conjunction of old and new, savage
and civilized, primitive and modern.

The film vividly portrays the issues surrounding avant-garde
artists' aspirations for the future, and the radical ways they wished to
change their lives by moving away from those aspects of modernity
that had resulted in the First World War. Raymond Roussel's
Impressions of Africa, Marcel Duchamp's Rrose Sélavy, Constantin
Brancusi's *Beginning of the World*, Fernand Léger's *The Creation of the
World* designs, Michel Leiris's *L'Afrique fantôme* and Léon Poirier's
Cain are all about a fresh start for the European. And yet, they all
manifest the tensions and contradictions that stamp them as being part
of that very same modernity.

Negrophilia has shown how blackness played a significant role in avant-garde definitions of modernity. But it was a modernity that hinged on this contradiction of regression to a primitive state predating Western civilization. Participation in black culture meant rejuvenation and liberation from the trappings of bourgeois values. But it was the 'idea' of black culture and not black culture itself that informed this modernity. Ironically, blacks were also caught up in these stereotypes. Their blackness qualified them for modernity, but to participate in it they had to negotiate, straddle, distort and deny their identities to accommodate European ideas about the primitive. Harlem's New Negroes had difficulty dealing with the avant-garde's preconceived ideas about black people and Africa. The images and literature of Harlem's intellectuals defined their own modern lives differently, as being part of city life and Western civilization. In many instances, it was white liberals who tutored blacks about primitivism, and, as Nathan Huggins notes,

'Un véritable tableau moderne', the crew of *Cain* filming in the jungle, from *L'Art vivant*, 15 November 1930

'Contrary to assertions of the soul community of blacks, the American Negroes had to learn to appreciate the value of African art and culture'.[8] Both blacks and whites struggled to come to terms with these differing aspirations; notions of the continent of Africa as an object of desire, whether as homeland or source of fantasy, were to become significant to both races, a haven for a diaspora that was both black and white and increasingly transcultural.

How blacks adapted to and contributed to European culture, whether through their experiences of slavery, New World migration or post-modern pluralism, has become an interesting feature of recent research, such as Paul Gilroy's *The Black Atlantic*,[9] Tyler Stovall's *Paris Noir*[10] and the collected essays in *Rhapsodies in Black: Art of the Harlem Renaissance*.[11] Such studies fill gaps in the fused history of blacks and whites. They represent attempts to assert the black presence in debates about modernity.[12] They also make the significant point that what made black people modern was the fact of the diaspora, their transcultural state, their restless (dis)continuity and the possibility of their cultural mutation. The blacks who travelled to Paris carried with them the burdens and blessings of these contradictions, they came in search of acceptance within a modern milieu that would respect the peculiar hybrid nature of their creativity. But their desire to be cultural insiders was confounded by members of the white avant-garde, who were striving to be outsiders. The lives of both these groups in Paris were not exclusive of each other, and their aspirations resulted in text and imagery that shared the same goal of modernity, even though they viewed it differently.

Many issues about black and white relationships were not new in the 1920s. They had been festering since Europe began its domination of the Atlantic centuries before. But these issues had been a problem only for the New World colonies, since Europe remained aloof. Gradually, however, the problem returned to haunt Europe. *Negrophilia*'s images follow the transformation of the black persona from a distant, often derogatory fiction of the imagination into something more compelling because of its proximity and reality. This book may have gone some way to explore these ideas and images. It has presented but a single moment in history when the motives, thoughts and actions of blacks and whites interfaced.

Today, Gauguin's question 'Where are we going?' is as relevant as it was earlier in the century, although, in a shrinking world, escape to a paradise island is no longer an option. In urban communities, blacks and whites live side by side, and whites now bear many of the cultural con-

tradictions that are an inevitable result of their engagement with blacks and modernity. Inevitably, that point of entanglement repeats itself as it has done throughout history, among the young, in the realms of popular culture, fashion, music and dance. History repeats itself with every raised eyebrow and with every concern about racial and cultural contamination. History repeats itself when 'white boys' wear locks, when heavy-metal performers appear on the same stage as hip-hop stars and call each other 'brother'. History repeats itself when, at the beginning of yet another century, the question 'Where are we going?' still remains as provocative as ever and still brings differing answers.

Negrophilia's imagery cannot be looked at dispassionately. For it to be released from the fear that obscures our understanding it must be engaged with intimately. If that fear is a result of racism, then that, too, must be exorcized. In order to do this, the book has used another voice, one that is 'collective' and non-European. This voice conveys a sense of the 'we' that has been muted in the past and more often represented as 'them'. This 'global' view redefines the 1920s and confidently asserts the presence of the black model not as something alien and other, but as integral to the European experience of modernity. While condemning the exoticism and racism inherent in the avant-garde's fantasies, it recognizes that black culture was a catalyst for change and philosophical upheaval. By discolouring past reconstructions of the 1920s in this way, *Negrophilia* has attempted to reconstruct truer images of whites and blacks in that decade.

GENTLEMAN, for the first time viewing a work of African
sculpture: "What sort of a woman is that?"

"To Hold, as t'Were the Mirror Up to Nature"

MIGUEL COVARRUBIAS 'To Hold as t'Were the Mirror
Up to Nature', from *Vanity Fair*, 1929

There seems no more appropriate way to end this discussion on negrophilia in the 1920s than to construct an anthology of texts from the era. The following is a series of fragments from *Negro* and other books loosely linked together, as so many experiences of the blacks and whites were at this time. But, rather than merely present them, they have been recomposed to explore issues of identity and to amplify the black voice and its message of protest.

France's attitude towards the color question is one that other countries might well emulate, though this statement does not excuse her colonial policy. I do whole-heartedly commend the attitude of the French as a nation towards black people in France. To be colored in France is never a mark of inferiority.

Henry Crowder, 'Where color prejudice is not a creed', *Negro*, p. 116

That night I removed all of my clothes. As time passed I began to feel increasingly comfortable with Paul – as I called him. I spent many happy hours in his quiet studio. Paul gave me confidence. For the first time in my life, I felt beautiful.

Josephine Baker, *Josephine*, p. 50

The colored girls today have learned the trick of dress very ably.... And the vivacity, the awareness of manner is like nothing the white can offer. The American white girl today is shop-worn compared to the Negro girl.

William Carlos Williams, 'The colored girls of Passenack – old and new', *Negro*, p. 72

And as there were civilised white monkeys, so were there black monkeys, created by the conquests of civilisation, learning to imitate the white and even beating them at their game. He recalled the colored sweetmen and touts and girls with whom he

had been familiar in America, some lived in the great obscure region of the boundary between white and black.

Claude McKay, *Banjo*, p. 212

There are also many superior persons of remote Negro connection who, because of group loyalty and a sense of duty, refuse to leave the Negro race. But the vast majority, that is the average octoroon, has a practical and unsentimental view of the situation. He rightfully feels he is entitled to his share of white opportunities. The families of the latter usually aid rather than hinder the passage out of their group. They are glad to have their light-skinned relations escape the insults and economic disadvantages whose deadening and tragic effects they know only too well.

Heba Janeth, 'America's changing color line', *Negro*, p. 61

Mr Barnes on art sounded like my father talking about business – only Mr Barnes was interested in painting. He and Mr Munro were very up on it. But I ordered some *fraises de bois* and thought about Mary, way off in London, as I ate them, because I didn't know anything about modern art then, so my mind wandered.

Langston Hughes, *The Big Sea*, p. 185

The woman who owned the studio was a Nordic of Scandinavia. The artist by whom I was recommended said that she was worried about engaging me because there were *américaines* in the class. They were the best-paying students, and I belonged to a savage race, she didn't know if I could behave.

Claude McKay, *Banjo*, p. 129

So I found a boxing booth owned by a man named Tom Taylor at Pontypridd and he saw me knocking around the show and called out to me: I say black fellow can you fight? I said: let someone jump on me and they will see. So as it happened it was Peter Brown, the middle-weight champion of England who was to meet a coloured boy by the name of Frank Craig the coffee cooler and he did not turn up so I took his place and Brown quit in the 5th round, so I was signed on and hailed as a champion.

Bob Scanlon, 'The record of a negro boxer', *Negro*, p. 208

In the early part of of the evening Florence [Mills] would often laugh and talk with the waiter and the musicians, or with Bruce and me – but an hour later be as remote as you please to a party of well-to-do tourists from Wisconsin, spending a thousand francs at the front table. It was the first time I had ever seen a colored person snubbing white people, so it always amused me no end to watch Florence move away from a table of money-spending Americans, who wanted nothing in the world so much as to have her sit down with them.

Langston Hughes, *The Big Sea*, p. 161

A winter spent in Nice, he had found the *cocottes* and gigolos monkeying on the promenade more interesting to watch than the society people. The white monkeys were essential to the great passion play of life to understudy the parts of those who were holding the stage by power of wealth, place, name, title, and class – everything but the real thing.

Claude McKay, *Banjo*, p. 212

But not so the Africans who were closer to the bush, the jungle, where their primitive sex life had been controlled by ancient tribal taboos.... Released from their taboos, turned loose in an atmosphere of prostitution and perversion and trying to imitate the white monkeys, it was no wonder they were very ugly.

Claude McKay, *Banjo*, p. 212

When the Negroes who knew the Black-bottom in its cradle saw the Broadway version they asked each other, "Is you learnt dat *new* Black Bottom yet?" Proof that it was not *their* dance.

Zora Neale Hurston, 'Characteristics of negro expression', *Negro*, p. 31

Notes and Sources

Introduction

Notes to pages 8-21

1. The word 'negrophilia' has been adapted from Jean Laude's use of the word '*négrophilie*', the title of the final chapter in his book *La Peinture française (1905-1914) et l'art nègre* (Paris, 1968). More recently, the term has been used by James Clifford in his essay 'Negrophilia', in *A New History of French Literature* (Cambridge, Mass., 1989), and also by the organizers of 'White on Black: Images of Blacks in Popular Culture – An Exhibition of the Negrophilia Collection', an exhibition of a private collection of black artistic memorabilia, held at the Tropenmuseum, Amsterdam, December 1989–August 1990.
2. William Rubin, 'Modernist primitivism: an introduction', in William Rubin (ed.), *"Primitivism" in 20th Century Art: Affinity of the Tribal and the Modern* (New York, 1984), vol. 1, pp. 1–81.
3. For a critique of the negritude movement, see René Depestre, *Bonjour et adieu à la négritude* (Paris, 1980).
4. Edward W. Said, *Orientalism* (London, 1978).
5. W. E. B. Du Bois, 'Returning soldiers', *Crisis*, XVIII, May 1919, pp. 13–14.
6. Claude McKay, *Banjo: A Story Without a Plot* (New York, 1929).
7. Henry Crowder, 'Where color prejudice is not a creed', in Nancy Cunard (ed.), *Negro: An Anthology* (London, 1934; abridged edition, New York, 1970 and 1996).
8. James Weldon Johnson, *Along this Way* (New York, 1933), p. 209.
9. Paul Gilroy, *The Black Atlantic: Modernity and Double Consciousness* (London, 1993).

Chapter One

Packaging the primitive

Notes to pages 22-49

1. Genesis 9:18-27.
2. William B. Cohen, *The French Encounter with Africans: White Response to Blacks, 1530-1880* (Bloomington, Indiana, and London, 1980) p. 65.
3. Charles Darwin, *On the Origin of Species by Means of Natural Selection* (London, 1859) and *The Descent of Man* (London, 1871).
4. Count Joseph Arthur de Gobineau, *Essai sur l'inégalité des races humaines* (Paris, 1853–5).
5. Helen D. Weston, 'Representing the right to represent: the portrait of Citizen Belley, ex-representative of the colonies, by A.-L. Girodet', *Res*, no. 26, Autumn 1994, pp. 84–99.
6. For recent views on Livingston and his travels in Africa, see Tim Jeal (ed.), *David Livingston and the Victorian Encounter with Africa* (London, 1996). In particular, Tim Barringer's essay 'Fabricating Africa: Livingstone and the visual image 1850–1874' shows how ideas about Africa in the imagination of the Victorian public were informed by colonial imagery.
7. See Jean-Louis Paudrat, 'From Africa', in William Rubin (ed.), op. cit., p. 133.
8. As described by Charles Ageron in 'L'Exposition coloniale de 1931: mythe républicain ou mythe impérial', *Les Lieux du mémoire* (Paris, 1984), vol. 1.
9. Annie Coombes, 'Ethnography and national and cultural identities', in Susan Hiller (ed.), *The Myth of Primitivism: Perspectives on Art* (London and New York, 1991), p. 192.
10. Raymond Bachollet, Jean-Barthélemi Debost, Anne-Claude Lelieur, Marie-Christine Peyrière, *Négripub: l'image des Noirs dans la publicité* (Paris, 1992), pp. 90–103.
11. See Nathan Huggins, *Harlem Renaissance* (New York, 1971), p. 282.
12. Ibid., pp. 288–99.
13. See *Le Rire*, vol. 2, no. 73, 28 March 1896; see also Toulouse-Lautrec's lithograph *Footit et Chocolat*, 1895.
14. John Kisch and Edward Mapp, *A Separate Cinema: Fifty Years of Black Cast Posters* (New York, 1992), p. xiii.
15. Nathan Huggins, op. cit., p. 273.
16. See Roger Lloyd Conover, 'Arthur Cravan: stances of the century', in David Chandler, John Gill, Tania Guha and Gilane Tawadros (eds), *Boxer* (London, 1996), p. 101.
17. Ibid., p.103.

Chapter Two
Fetishism and fashion
Notes to pages 50–79

1. Anthony Shelton (ed.), *Fetishism: Visualising Power and Desire* (London, 1995).
2. For a compelling discussion about Paul Gauguin's bid for avant-garde status using ideas of the primitive and gendered imagery, see Griselda Pollock, *Avant-Garde Gambits 1888–1893: Gender and the Colour of Art History* (London, 1992).
3. See Leo Steinberg, 'The philosophical brothel', *Art News*, September 1972, pp. 20–9, part 1, and October 1972, pp. 38–47, part 2.
4. Pablo Picasso to André Malraux, originally recorded in French in *La Tête d'Obsidienne* (Paris, 1936), p. 17, and later translated into English in André Malraux, *Picasso's Masks*, trans. J. Guicharnaud (Paris, 1974), p. 10–11.
5. Dora Vallier, 'Braque, la peinture et nous', *Cahiers d'art*, vol. 29, nos. 1 and 2, October 1954, p. 14.
6. Jean-Louis Paudrat, op. cit., pp. 143–4.
7. See Gareth Stanton, 'The oriental city: a North African itinerary', *Third Text*, no. 3/4, Spring/Summer 1988, p. 3ff.
8. See Tristan Tzara, 'Notes on negro art', in *Seven Dada Manifestos and Lampisteries* (London, 1977), p. 57.
9. See Ileana B. Leavens, *From "291" to Zurich: The Birth of Dada* (Ann Arbor, Michigan, 1983).
10. Carl Einstein, *Negerplastik* (Leipzig, 1915).
11. Paul Guillaume and Guillaume Apollinaire, *Sculptures nègres* (Paris, 1917).
12. Henri Clouzot and André Level, *L'Art nègre et l'art océanien* (Paris, 1919).
13. Roger Fry, 'Negro sculpture', in *Vision and Design* (London, 1920).
14. Marius de Zayas, *African Negro Art and its Influence on Modern Art* (New York, 1916).
15. See James Clifford's essay 'On ethnographic surrealism', in *The Predicament of Culture: Twentieth-Century Ethnography, Literature, and Art* (Cambridge, Mass., and London, 1988).
16. For a comprehensive discussion about the idea of connoisseurship, see Sally Price, *Primitive Art in Civilized Places* (Chicago and London, 1989).
17. An important study of the influence of Guillaume Apollinaire is Katia Samaltanos, *Apollinaire: Catalyst for Primitivism, Picabia, and Duchamp* (Ann Arbor, Michigan, 1984).
18. Paul Guillaume (ed.), *Les Arts à Paris*, nos. 1–20, 1918–33.
19. *Les Arts à Paris*, no. 3, 1918, p. 2.
20. *Les Arts à Paris*, no. 5, 1919, p. 4.
21. See Paul Guillaume, 'African art at the Barnes Foundation', *Les Arts à Paris*, no. 8, 1923, pp. 9–10, and also Albert C. Barnes, 'L'art nègre et l'Amérique, *Les Arts à Paris*, no. 9, 1924, p. 2.
22. Paul Guillaume, 'The triumph of ancient negro art', *Opportunity: Journal of Negro Life*, vol. 4, no. 41, May 1926.
23. Paul Guillaume, 'Une ésthétique nouvelle: l'art nègre', *Les Arts à Paris*, no. 4, 1919, p. 14.
24. Paul Guillaume, 'The discovery and appreciation of primitive negro sculpture', *Les Arts à Paris*, no. 12, May 1926.
25. *Les Arts à Paris*, no. 4, 1919, p. 14.
26. Pierre Cabanne and Pierre Rastany, *L'Avant-garde au XXème siècle* (Paris, 1969).
27. Jean Cocteau, *Rappel à l'ordre* (Paris, 1926).
28. See 'Ruhlmannisme', *Art présent*, no. 1, 1945, p. 68.
29. 'Le cabinet de travaille d'un voyageur', *Vogue* (Paris), December 1927, p. 31.
30. Georges-Marie Haardt and Louis Audouin-Dubreuil, *The Black Journey: Across Central Africa with the Citroën Expedition* (London, 1928).
31. Alexandre Iacovleff, *Déssins et peintures d'Afrique* (Paris, 1927).
32. Georges-Marie Haardt, photograph album, vol. 4, nos. 1321–4.
33. Georges-Marie Haardt and Louis Audouin-Dubreuil, op. cit., p. 200.
34. A term aptly coined by Rosalind Krauss, see her essay 'Giacometti', in William Rubin (ed.), op. cit.
35. For more complete biographical details on Sonia Delaunay, see Arthur A. Cohen, *Sonia Delaunay* (New York, 1975).
36. See Robert Delaunay, 'The simultaneous fabrics of Sonia Delaunay' (1938), reproduced in Arthur A. Cohen (ed.), *The New Art of Color: The Writings of Robert and Sonia Delaunay* (New York, 1978).
37. Quotation reproduced by Lynne Thornton in 'Negro art and the furniture of Pierre-Émile Legrain', *The Connoisseur*, November 1972, p. 166.
38. See Jean-François Revel, 'Jacques Doucet, couturier et collectionneur', *L'Œil*, no. 84, December 1961, pp. 44–81.
39. For a more detailed discussion about African art's influence on Legrain's furniture, see Lynne Thornton, op. cit., p. 166.
40. Ibid.
41. Thomas Crow, 'Modernism and mass culture in the visual arts', in Benjamin H. D. Buchloh, Serge Guilbaut and David Solkin (eds), *Modernism and Modernity: The Vancouver Conference Papers* (Halifax, Nova Scotia, 1983), pp. 215–64.
42. 'Parure', in *Encyclopédie des arts décoratifs et industriels modernes au XXème siècle*, vol. 9 (Paris, 1925), reprinted as *Costume and Design:*

Exposition internationale des arts décoratifs et industriels modernes (New York, 1977), p. 22.

43. For a general discussion about fashion during this era, see Madeleine Ginsberg, *Paris Fashions: The Art Deco Style of the 1920s* (London, 1989).

Chapter Three
Negrophiles, photographs and fantasies
Notes to pages 80–105

1. 'Letter from Paris', *Vogue* (London), May 1926, pp. 48–9.
2. Jean-Hubert Martin, *Man Ray* (London, 1982).
3. Jeffrey S. Weiss, 'Picasso, collage, and the music hall', in Kirk Varnedoe and Adam Gopnik, *High and Low: Modern Art and Popular Culture* (New York, 1993).
4. Guillaume Apollinaire, *Le Poète assassiné* (Paris, 1916), pp. 75–7.
5. Raymond Roussel, *Impressions d'Afrique* (Paris, 1910), translated from the French by Lindy Foord and Rayner Heppenstall as *Impressions of Africa* (London, 1966).
6. Guillaume Apollinaire, *Les Mamelles de Tirésias* (Paris, 1917; 2nd edition, with illustrations by Pablo Picasso, Paris, 1946).
7. Guillaume Apollinaire, 'Exoticism and ethnography', *Paris Journal*, 12 September 1912, translated in L. Breunig, *Apollinaire on Art: Essays and Reviews 1902–1918* (New York, 1972), pp. 243–6.
8. Sally Price, op. cit.
9. See Laura Rosenstock, 'Léger: *The Creation of the World*', in William Rubin (ed.), op. cit.
10. Michel Leiris, *L'Afrique fantôme* (Paris, 1934).
11. Nancy Cunard to Janet Flanner, 10 March 1926, as cited by Ann Chisholm, *Nancy Cunard: A Biography* (London, 1979), p. 101.
12. 'Ivory shackles', *Vogue* (London), 1926, as cited by Ann Chisholm, op. cit., p. 98.
13. Stephen Papich, *Remembering Josephine Baker* (Indianapolis, 1976).
14. Frantz Fanon, *Black Skin, White Masks*, translated from the French by Charles Markmann (London, 1986).
15. Georges Thiry, 'Antoine, photographe nègre', *Jazz*, 1929, pp. 485–6.

Chapter Four
L'art jazz and the black bottom
Notes to pages 106–133

1. Joel A. Rogers, 'Jazz at home', in Alain Locke (ed.), *The New Negro* (New York, 1925).
2. Laura Rosenstock, op. cit.
3. Blaise Cendrars, *Anthologie nègre* (Paris, 1921).

4. Blaise Cendrars, *La Fin du monde*, with colour illustrations by Fernand Léger (Paris, 1919).
5. Taken from Blaise Cendrars, op. cit., 1921.
6. Carl Einstein, op. cit.
7. Marius de Zayas, op. cit.
8. André Cœuroy, 'Le jazz', *L'Art vivant*, vol. 2, 1926.
9. André Levinson, *La Danse d'aujourd'hui: Études, notes, portraits* (Paris, 1929).
10. Josephine Baker and Jo Bouillon, *Josephine*, translated by Mariana Fitzpatrick (London, 1978), p. 63.
11. Extract from André Levinson, 'Danses nègres', *L'Art vivant*, 1 February 1927, pp. 115–16, also published in English as 'The negro dance under European eyes', *Theatre Arts Monthly*, April 1927.
12. Josephine Baker, 'Topic of the day', in Paul Colin, *Le Tumulte noir* (Paris, 1927).
13. Marcel Sauvage, 'Préface', in Paul Colin, op. cit.
14. Homi K. Bhabha, 'The Other question: the stereotype and colonial discourse', *Screen*, vol. 24, no. 6, 1983, pp. 18–36.
15. For an extensive discussion about nineteenth-century imaging of black and white women, see Sander Gilman, 'Black bodies, white bodies: toward an iconography of female sexuality in late nineteenth-century art, medicine and literature', *Critical Inquiry*, vol. 12, no. 1, Autumn 1985, pp. 204–42.
16. Josephine kept a menagerie, and sported a pet leopard on a leash.
17. Pierre de Regnier, *Candide*, 12 November 1925, as cited in Marcel Sauvage, *Les Mémoires de Josephine: recueillés et adaptés par Marcel Sauvage, avec 30 déssins de Paul Colin* (Paris, 1927), p. 16.
18. André Breton et al., 'Ne visitez pas l'Exposition coloniale' (Paris, 1931).
19. Pepito Abatino, 'Josephine Baker vue en 1925 et 1930' (Paris, 1930).

Chapter Five
The darker side of surrealism
Notes to pages 134–157

1. See Rosalind Krauss, op. cit.
2. Georges Bataille, Michel Leiris, Carl Einstein (eds), *Documents*, 1929–31.
3. See, in particular, Katherine Jansky-Michaelson, 'Brancusi and African art', *Art Forum*, November 1971, pp. 72–7, and Edith Balas, 'The sculpture of Brancusi in the light of his Rumanian heritage', *Art Journal*, no. 35/2, Winter 1975–6, pp. 94–105.
4. Laura Rosenstock, op. cit.
5. Man Ray, *Self-Portrait* (London, 1988), p. 128.
6. These ideas are an extrapolation of Eric Shanes's 'Brancusi and the caryatid: raising ideals onto a pedestal', *Apollo*, CXXXVI, no. 366, August 1992,

which suggests Brancusi's interest in platonic ideals, but does not relate them to African art.

7. Michel Leiris, 'Civilisation', *Documents*, 1929, no. 4.
8. André Breton, *The Second Manifesto of Surrealism* (Paris, 1929).
9. Rosalind Krauss, op. cit., pp. 503–33.
10. William B. Seabrook, *Magic Island* (New York, 1929).
11. Paul Morand, 'W. B. Seabrook: romancier américain', *Les Nouvelles littéraires*, 28 September 1929, p. 2.
12. J. Michael Dash, *Haiti and the United States: National Stereotypes and the Literary Imagination* (London, 1988), p. 31.
13. See James Clifford's discussion about Leiris's travel fantasies in his *The Predicament of Culture*, op. cit., pp. 165–74.
14. Michel Leiris, 'L'Île magique', *Documents*, 1929, no. 6.
15. Michel Leiris, 'Le "caput mortuum" ou la femme de l'alchimiste', *Documents*, 1930, no. 8.
16. Michel Leiris, 'Alberto Giacometti', 1929, no. 4.
17. *Cahiers d'art* was a monthly arts journal, edited by Christian Zervos, which after 1926 regularly featured art from other cultures and showed a particular interest in African art. See, for example, two special editions – nos. 7 and 8 (both 1927) – devoted to *l'art nègre*.
18. DuBose Heyward, *Porgy* (New York, 1925).
19. Paul Morand, op. cit., p. 2.
20. André Levinson, 'Aframérique', *Les Nouvelles littéraires*, 31 August 1929.
21. André Levinson, '*Porgy* et la *Revue des Oiseaux Noir*', *L'Art vivant*, 15 July 1929, p. 577.
22. André Schæffner, 'Les "Lew Leslie's Black Birds" au Moulin Rouge', *Documents*, 1929, no. 4.
23. *Le Surréalisme au service de la révolution*, no. 4, December 1931.
24. For a more detailed discussion about surrealism's relationship to the Caribbean, see Michael Richards (ed.), *Refusal of the Shadow: Surrealism and the Caribbean* (London, 1996).

Chapter Six
'Other' lovers in Paris and New York
Notes to pages 158–177
1. Nancy Cunard (ed.), op. cit., 1934.
2. Carl Van Vechten, *Nigger Heaven* (New York, 1926).
3. Joel A. Rogers, 'The Paris pepper pot', *Pittsburgh Courier*, 27 July 1929.
4. Joel A. Rogers, *Pittsburgh Courier*, 17 August 1929.
5. See Catherine Bernard, 'Confluence: Harlem Renaissance, modernism, negritude, Paris in the 1920s and 30s', in *Exploration in the City of Light: African-American Artists in Paris 1945–1965*, exh. cat., The Studio Museum in Harlem (New York, 1996).

6. Claude McKay, op. cit., 1929.
7. Langston Hughes, *The Big Sea* (New York and London, 1940).
8. Claude McKay, *A Long Way From Home* (New York, 1937).
9. Ann Chisholm, op. cit.
10. Hugh Ford, Introduction to Nancy Cunard (ed.), op. cit., 1970 and 1996.
11. Winston Churchill, *My African Journey* (London, 1908).
12. Harry Johnston, *Negro in the New World* (London, 1910).
13. Michel Leiris, op. cit., 1934.
14. Nancy Cunard, 'Jamaica: the negro island', in Nancy Cunard (ed.), op. cit., 1934.
15. All excerpts from Van Vechten's writings are taken from Bruce Kellner (ed.), *Letters of Carl Van Vechten* (New Haven and London, 1987).
16. James Weldon Johnson, op. cit.
17. Claude McKay, op. cit., 1937.
18. Jeffrey C. Stewart, 'Paul Robeson and the problem of modernism', in Joanna Skipworth (ed.), *Rhapsodies in Black: Art of the Harlem Renaissance*, exh. cat., Hayward Gallery (London, 1997).
19. Langston Hughes, 'House in the world', in Nancy Cunard (ed.), op. cit., 1970 and 1996, p. 263.

Conclusion
Notes to pages 178–184
1. G. H. Luquet, *L'Art primitif* (Paris, 1930).
2. Hans Prinzhorn, *Bildnerei der Geisteskranken* (2nd edition, Berlin, 1923).
3. For a lineage of artists whose works stem from a form of European- rather than African-influenced primitivism, see Lynne Cooke, 'Neo-Primitivism: a regression to the domain of the "night mind" or adolescent persiflage?', *Artscribe*, March–April 1985, pp. 16–24.
4. See 'Le cinéma art vivant et la réalisation de *Cain*' and also 'Synopsis de *Cain*: aventures des mers exotiques', *L'Art vivant*, 15 November 1930, pp. 883–917.
5. The film starred Thomy Boudelle as Cain and Rama Tahe (from Guadaloupe) as Zouzour.
6. From the title of Gauguin's 1897 painting *D'où venons-nous? Que sommes-nous? Où allons-nous?*
7. Paul Gilroy, op. cit., p. 4.
8. Nathan Huggins, op. cit., p. 187.
9. Paul Gilroy, op. cit.
10. Tyler Stovall, *Paris Noir: African-Americans in the City of Light* (Boston, 1996).
11. Joanna Skipworth (ed.), op. cit.
12. See, in particular, Paul Gilroy, op. cit., pp. 30–40.

List of Illustrations

Index